AN OPINIONATED GUIDE

British Art

HOXTON MINI PRESS

Who cares

about

British Art?

Is British Art unique, or special? The idea of a 'national character' feels antiquated today. Once gluey ideologies about 'Britishness' touted in the days of empire-building have fewer and fewer followers. Besides, great artworks surrender their secrets and splendours without the need for categories and the presumptions they bring.

If anything, British Art has been a conversation. Ideas flowing and echoing, being adapted and made new. Ben Nicholson (p.96) was sensitive to Picasso, Frank Bowling (p.114) had the Abstract Expressionists in mind, as van Dyck (p.32) had Titian. Even the monk Eadfrith (p.18), who spent his life on an island in the North Sea, wove German elements into his illuminated manuscripts.

Some patterns and threads recur, though: a sensitivity to tiny shifts in the light, shadows and colours of a landscape, a flair for storytelling and for satire. A habit of breaking the rules. There may be something in the mostly sodden atmosphere after all. A wild alchemy of place that has bled into the imaginations of people who live or spend a while here, producing some of the world's most arresting, most progressive and most captivating art.

Timeline of British Art

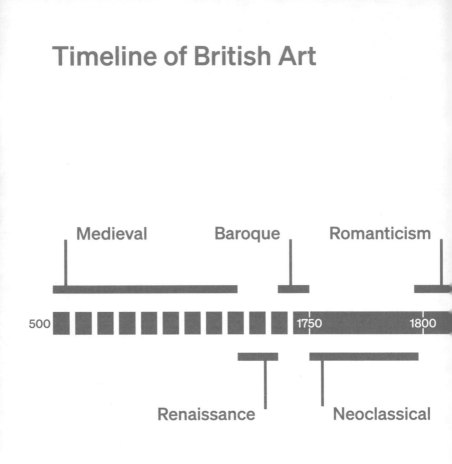

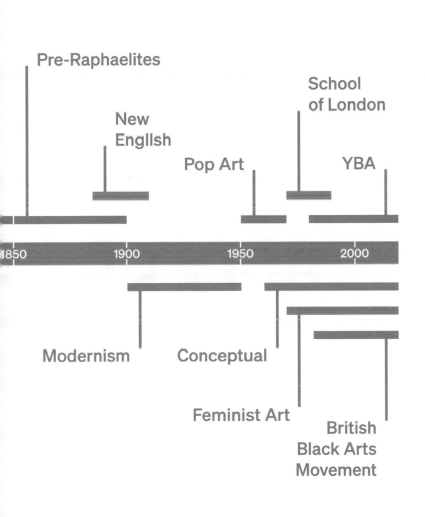

Pre-Raphaelites

New
Engllsh

Pop Art

School
of London

YBA

850 1900 1950 2000

Modernism Conceptual

Feminist Art

British
Black Arts
Movement

The short

story of

British Art

When British Art begins is tricky. So little survives from the critical years in which the island began to emerge from the shadow of Roman occupation. We favoured wood over stone; itinerant living over places to furnish.

Something like an identity begins to curdle in Anglo-Saxon times, with the Sutton Hoo hoard and the Lindisfarne Gospels (p.18), whose delicate artistry remains present in Britain's visual culture for centuries afterwards.

How we get from there, though, to Enlightenment painters working by candlelight to convey 'the Pleasures of Science' (p.42) or the anatomy of a horse (p.40); 'the whiff of leather and stout' in Victorian music halls (p.68) and a tiger shark in a glass vitrine (p.120) is a journey as strange as it is exhilarating.

Following that journey here you begin to glean its reverberations and its relationships. How certain artists taught each other, fought with each other and hung each other's work on their walls – often centuries apart. That interconnectedness, the absorption of one painting into another and yet another makes the story far from straightforward, but always captivating.

Key movements

Medieval *500–1400*

It's often referred to as the Dark Ages, but this period between the fall of the Roman Empire and the rebirth of classical learning in the 15th century is full of beautiful art. As Christianity flourished, the most influential members of society commissioned cathedrals, textiles, illuminated manuscripts and jewellery to reflect the new worldview. Britain became especially renowned for the quality of its embroidery and tapestries – an art that *The Vanity of Small Differences* (p.136) is in conversation with in the present day. Unfortunately, thanks to Viking raids and the Reformation, very little survives.

Renaissance *1400–1600*

Beginning in 14th century Florence, a revival of interest in Ancient Greek and Roman culture inspired a return to classical ideals, such as logic and humanism, radically changing art throughout Europe. An enriched under-standing of nature, perspective and anatomy led to a higher degree of naturalism and a new focus on portraiture, while secular subjects – classical myths, history, battles – began to replace religious ones. In Britain, the Renaissance coincided with the rise of the Tudors (thanks mostly to Holbein's arrival here from Germany, p.22) and peaked in the reign of Elizabeth I.

Baroque *1600–1750*

An exuberant, ornate style that appealed to the emotions, the Baroque movement also began in Italy, this time in Rome, where the Catholic Church was intent on making a consummate statement of majesty. Baroque's grand scale and theatricality were perfectly suited to conveying status and power, and it wasn't long before royalty and aristocracy harnessed it for their own use. In Britain, the Baroque artist Anthony van Dyck (p.32) became the leading court painter. His grandiose portraits of Charles I set a new standard for English portraiture, and British painters quickly followed suit.

Neoclassical *1750–1790*

Baroque's frivolity (all those wigs and golden clouds) always sat a little awkwardly in Britain. Neoclassicism fared much better: an austere, restrained style inspired by the discovery of the Ancient Roman cities of Herculaneum and Pompeii. Neoclassical artists such as Joshua Reynolds (p.46) borrowed poses and symbolism from an-cient sculptures and vases, and themes from classical myths.

Romanticism *1780–1850*

To the Romantics, neoclassicism seemed overly restrictive. They preferred the untamed imagination and wild, sublime landscapes. In this period, John Constable (p.52) became one of the first artists to paint outside, immersed in the landscape. Meanwhile, unprecedented growth in industry and technology prompted a kind of spiritual yearning. William Blake in particular used his visionary paintings to pour cold water on science (p.50).

Pre-Raphaelites *1848–1900*

The Pre-Raphaelite Brotherhood, led by Dante Gabriel Rossetti (p.62), was bound by their admiration for Italian art before the time of Michelangelo and a desire to refute the neoclassical tradition embodied by their bête noire, Joshua Reynolds (p.46). They chose biblical and medieval literary themes, particularly those associated with love and death – also key themes for the Aesthetic artists of the 1890s, whose rejection of Victorian values led to the censorship and condemnation of figures including Oscar Wilde.

New English *1885–1910*

The New English Art Club (NEAC) was founded in 1885 by a group of artists dissatisfied with the turgid attitude of the dominant taste makers in the arts – the Royal Academy. Their aim was to exhibit 'really good modern painting' and the group became a haven for adventurous artists including Gwen John (p.70) and John Singer Sargent (p.64). Walter Sickert (p.68) was one of the most consistent exhibitors, showing over 130 paintings. He also founded the Camden Town Group, which sought to reflect modern urban life.

Modernism *1900–1950*

The NEAC was only one of many splinter groups that developed around the turn of the century to promote experimental styles of art. The next half century was char-acterised by a tumult of artistic 'isms' and innovations. Some, like the Vorticists (p.82) and Futurists, produced manifestos outlining their schools of thought, but most addressed in one form or another the speed and chaos of

modern life. In doing so, they reshaped the artistic landscape and shattered long-established conventions for good.

Pop Art *1950–1970*
Emerging from the gloom of post-war austerity, Pop Art embraced the glamour and optimism of American popular culture. Artists like Jann Haworth (p.108) and Peter Blake (p.106) repurposed imagery from mass-produced consumer culture, transforming everything from Hollywood movies, adverts, product packaging and comics into bold and playful artworks.

Conceptual *1960–present*
The origins of conceptual art – a broad name given to works in which the idea takes precedence over aesthetics – go all the way back to Marcel Duchamp's 1917 'readymade' sculpture *Fountain* – a urinal that he signed 'R. Mutt'. It's this intellectual game playing that's at the heart of conceptual art, which is less a movement than a mindset. It's often controversial (and actively sets out to be), challenging our assumptions about what art is. It can be funny and illuminating and unsettling, and with a virtuoso like Cornelia Parker (p.142), unutterably affecting.

School of London *1970–1990*
Around the same time that Pop Art was experimenting with consumerism, a group of loosely affiliated artists including Lucian Freud (p.98), Francis Bacon (p.100) and Frank Auerbach (p.132) chose to reject more fashionable abstraction and conceptualism in favour of figurative

painting and painterly techniques. Their works are characterised by rich textures and bold brushwork, challenging traditional notions of beauty. They frequently explored the complexities of human psychology with unflinching honesty.

Feminist Art *1970–present*
Feminist art emerged in the 1970s alongside the Women's Liberation Movement. Cultural expectations, domestic life and stereotyping were key themes, as women artists – and women more widely – sought recognition and equality. Feminist critics and artists dissected the gendered terminology of art history and reconsidered the role of the female nude, as well as the disparity in the ways we see men and women. Artists like Helen Chadwick (p.116) examined gender, identity and representation with wry works that were a huge influence on the subsequent generation of YBAs.

British Black Arts Movement *1982–present*
Founded in 1982, the British Black Arts Movement challenged the exclusion of non-white artists during a period of fraught race relations in Britain. Over the next few years, the country would be rocked by protests stemming from inequality and social tensions. Artists like Sonia Boyce (p.118) responded by fostering a sense of solidarity and empowerment, providing a platform for Black artists to assert their voices. Recognition was slow in coming, but emphatic when it came: in 2016 Boyce was elected to the Royal Academy, becoming the first female black British academician in the institution's almost 250-year long history.

YBA *1980–present*

The Young British Artists rose to prominence in the late 1980s and early 1990s with provocative work that challenged public taste and artistic convention. Nothing was off limits: preserved dead animals (p.120), frozen human blood and an artist's own unmade bed (p.128) were all deployed in work exploring themes like consumerism, sexuality and mortality. It was garish, crude and infernally clever – and, for a few years, made British artists the most famous on earth.

Where can I see it?

Yorkshire Sculpture Park, *Nr Wakefield* *ysp.org.uk*
Set within the 500-acre Bretton Hall estate, the YSP hosts
the most significant collection of modern and contempo-
rary British sculpture in the world. See monumental pieces
by Barbara Hepworth (p.92) and Phyllida Barlow (p.124) as
well as exhibitions of works by rising talents.

National Galleries Scotland, *Edinburgh* *nationalgalleries.org*
Understandably rich in Scottish art but also home to works
originating from the vibrant Scottish contemporary art
scene, including Glasgow alumnus David Shrigley (p.146),
plus paintings by luminaries of the canon such as John
Singer Sargent (p.64) and William Nicholson (p.72).

Tate Britain, *London* *tate.org.uk*
Recently rehung to reflect omissions in the canon, Tate
Britain displays more than 800 works by British artists.
Its neoclassical premises are your best bet for J.M.W.
Turner (p.58) – with 100 career-spanning works – and
stalwarts such as David Hockney (p.112), but also for more
curious fare, like the *Cholmondeley Ladies* (p.30) and –
periodically – Chris Ofili's spellbinding installation *The
Upper Room* (p.130).

National Portrait Gallery, *London* *npg.org.uk*
Following a three-year, £41 million makeover, the new NPG
is a stylish and inclusive telling of British history. Alongside

works by Hogarth (p.36) and Holbein (p.22) you'll find kings and queens aplenty, plus James Gillray's ruthless caricatures (p.48) and a pair of vast, beautiful new bronze doors by Tracey Emin (p.128), bearing casts of 45 female faces.

Pallant House Gallery, *Chichester* *pallant.org.uk*
It may be small but PHG is easily the greatest champion of modern British art in the country. The space – part Grade 1 listed townhouse, part modern glass – is warren-like, with one marvel-filled room opening onto another. Thoughtful displays of the permanent collection (including responses to it from contemporary artists) are complemented by an exhibition programme that celebrates overlooked artists.

Royal Academy of Arts, *London* *royalacademy.org.uk*
Founded on Enlightenment principles in 1768 by 36 eminent, if hot-tempered artists (led by Joshua Reynolds, p.46), the RA recently celebrated its 250th anniversary. Since the beginning it's hosted the must-see Summer Exhibition, where you can see floor-to-ceiling displays of new works by emerging artists and household names.

The Whitworth, *Manchester* *whitworth.manchester.ac.uk*
Built in 1889 for the 'perpetual gratification of the people of Manchester', the Whitworth draws on a collection of more than 60,000 artworks (including pivotal Pre-Raphaelite paintings) to create exhibitions on everything from migration to the attention economy as well as solo shows from living artists such as Cornelia Parker (p.142).

Contributors

Lucy Davies is the former visual arts editor of the *Telegraph*, and now a writer and curator based in London. She is the author of several books on painting and photography and a regular contributor to national newspapers and magazines. She's also written lots for Hoxton Mini Press.

Hoxton Mini Press is a small independent publisher from east London. Independent ... Yes! We believe in books. We believe in beautiful books. We believe in beautiful books that you collect and put on nice wooden shelves and keep for future generations. We also plant loads of trees.

About the series
In an age when everything can be researched online we believe that strong opinion is better than more information. The intention of these 'opinionated' books is not to tell you everything, it's to spark curiousity and maybe just lift your day a little.

Artworks

Lindisfarne Gospels, c.700

The manuscript that became an icon

Everyone should see the Lindisfarne Gospels at least once. The 1,300-year-old manuscript is as much a treasure as the Sutton Hoo or Staffordshire hoards – its Anglo-Saxon contemporaries – and much more mesmerising. Today the book resides in the British Library, though it is regularly removed from display for enforced 'rest' and travels only rarely. It has always enjoyed such fierce protection. The stories of its incredible rescue from drownings, Viking raids and the clutches of Thomas Cromwell's emissaries during the Dissolution of the Monasteries, are part of its charisma. Although more extraordinary is that its delicately scripted, elaborately decorated pages are the work of just one man: Eadfrith, Bishop of Lindisfarne. On that wind-whipped crumb of rock, in his bone-cold scriptoria, Eadfrith laboured on the Gospels for a decade. To each disciple, he gave a spectacular intro: first a portrait, then a 'carpet' page (a swirling, minutely detailed pattern that resembles an Ottoman rug) followed by an 'incipit' page, on which the text begins in large ornate letters. Here it's John: 'In the beginning was the word,' which, given Christianity, the religion of the book, was in the process of replacing older oral traditions, seems beautifully apt.

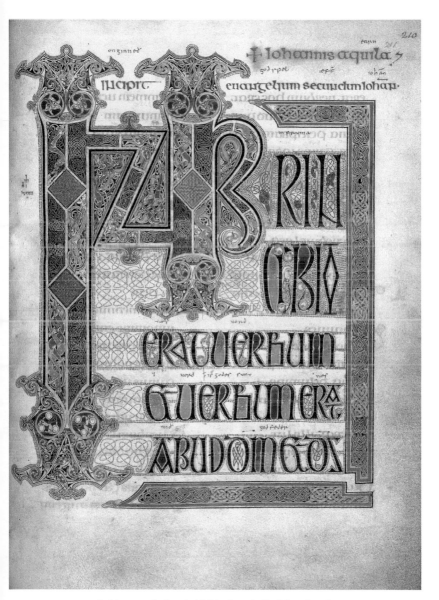

Incipit page to the Gospel of St John, from the *Lindisfarne Gospels*,
c.700, Bishop of Lindisfarne, parchment, British Library

The Wilton Diptych, c.1395–9

A portable artwork with a tiny secret

Made for King Richard II and named for Wilton House, near Salisbury, where this dazzler of an altarpiece resided between 1705 and 1929, the diptych touts Richard as ruler by divine appointment – a belief of his that did not endear him to his hut-dwelling subjects and did much to bring about his downfall. Courts were largely itinerant in the early Middle Ages, so the diptych is just 50cm tall and hinged for easy stowing, all of which makes its creamy finish and scrupulous brushwork (the brocade, the sweetly blushing cheeks, the flowers on the grass) even more astonishing. But what elevates it beyond every other altarpiece bumping about Europe in a royal saddle bag at this point is that its author (never reliably identified) has stuffed his work with puzzling symbols. Not least the tiny image (it is only a few centimetres wide) of England, hidden in the orb at the top of the standard. Discovered when the diptych was restored in 1993, it shows a turreted castle on an island, floating in a silver sea. If that's ringing bells, it's because Shakespeare's *Richard II* contains the line 'this little world, This precious stone set in a silver sea'. Tempting then to think that Shakespeare knew and admired it.

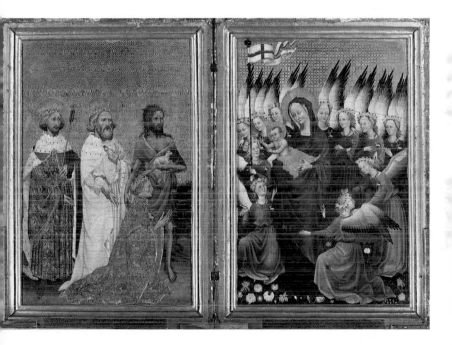

Panels of *The Wilton Diptych*, *c.*1395–9, Unknown artist,
egg tempera on oak, 530 × 370 mm, The National Gallery

The Ambassadors, 1533

A stately display of intellectual trickery

As much an intellectual game as a visual delight, this painting depicts two emissaries of the French king: ambassador Jean de Dinteville and his friend, Georges de Selve, Bishop of Lavaur. Given their high rank and patent self-assurance, it's startling to think they were only in their twenties when the painting was executed. Holbein was the star artist at the court of Henry VIII and a portraitist bar none. Our Tudor-mania is in no small part his doing, so vividly did he bring that era's courtiers, scholars and gentlewomen to life. But *The Ambassadors* isn't just a portrait, at least not exactly. It's also a cipher for the politically tumultuous, rapidly expanding world Holbein and his subjects had to navigate. After all, 1533 was the year Henry quarrelled with the Pope, then married and crowned Anne Boleyn – both ready tinder for Martin Luther's Reformation. The broken string on the lute here (lute, Luther) is one of several clues suggesting things were out of whack. Not the greatest moment to be a diplomat, then. As for the peculiar smear on the painting's lower half, viewed from the right edge it turns into a floating skull. In the face of death, says Holbein, all your fine objects and ambition will be nothing.

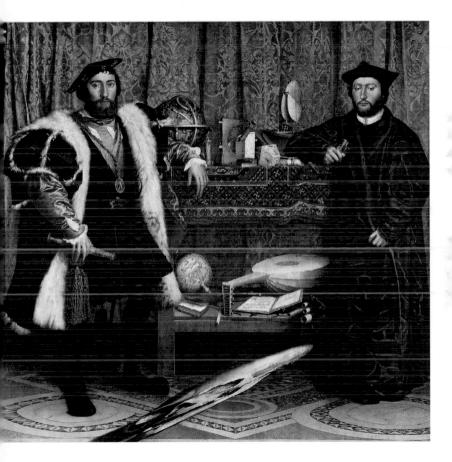

The Ambassadors, 1533, Hans Holbein the Younger, oil on panel, 2070×2095 mm, The National Gallery

The Field of the Cloth of Gold, *c.*1545

Propaganda with all the swagger of Henry VIII

In June 1520, two kings, thousands of nobles and their thousands of hangers-on gathered in a field near Calais, for revels. Henry VIII of England and François I of France had been strong-armed into the event by Cardinal Wolsey to cement the rival kingdoms' newfound accord. Henry commissioned this extraordinary, humungous canvas to record the event's braggy splendour for all the world – and posterity – to see. If you ever find yourself in front of it, get close and gawk because the detail is joyous: scrapping drunks, courtiers giving side-eye, the guards' just-look-at-me pants and pikes. Pride of place, however, is awarded to Henry's 'portable palace': an insane confection of canvas, timber and stained glass that was bigger than Hampton Court. It even had secret passages and a 300-ft banqueting hall. And if you're thinking the dragon is a piece of artistic whimsy, be amazed: it was a kite pulled by a rope tied to a carriage and filled with fireworks that made its eyes blaze and mouth smoke. The event was classed a success, but Tudors being Tudors, within a year Wolsey was putting his name to a secret treaty against the French. By the decade's end, he was out on his ear too.

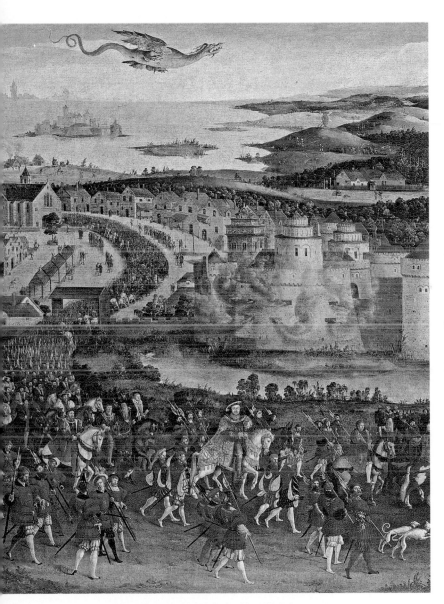

Detail from *The Field of the Cloth of Gold*, *c.*1545, Unknown artist,
oil on canvas, 1689 × 3473 mm, Royal Collection Trust

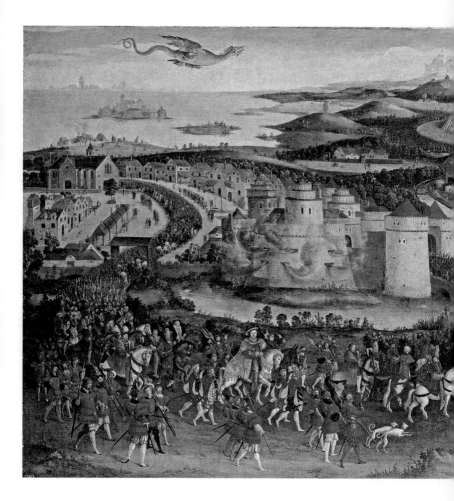

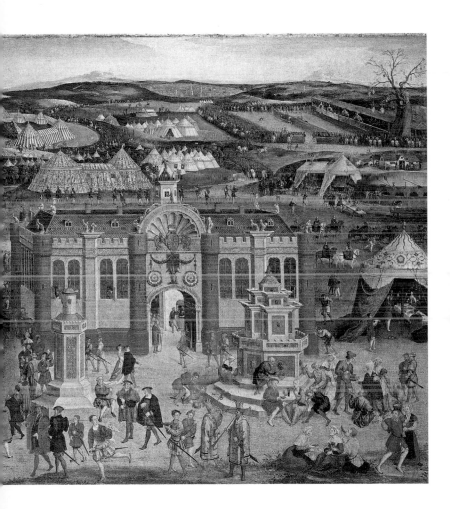

Portrait of a Young Man, 1588

Tousled nobleman by Britain's master of miniatures

Hillard is our first home-grown Renaissance master; the Devon-born man who hauled English art from anonymous provincialism to international esteem. He became miniature painter to Queen Elizabeth I in his early twenties (by the end of his life he could paint her face from memory), and courts all over Europe tried to poach him. The dashing, extravagantly collared gentleman here is thought to be Robert Devereux, Earl of Essex, great grandson of Mary Boleyn and – at the time Hilliard painted him – favourite of the Queen (she later tired of his ambition, called him a 'shameless ingrate', and signed his death warrant). The painting is incredible – a mere 1.5in. tall (about the same as the face of a Rolex) and yet so wonderfully exact and lifelike, you feel as if you would recognise Devereux if he passed you on the street. The secret, said Hilliard, in a treatise about 'limning' (as miniature painting was then known), published around the time Devereux's neck met the executioner's blade, was to try and capture 'those lovely graces, witty smilings, and those stolen glances which suddenly like lightning pass'. His secret weapon? None other than a 'pretty little tooth of some ferret or stoat'.

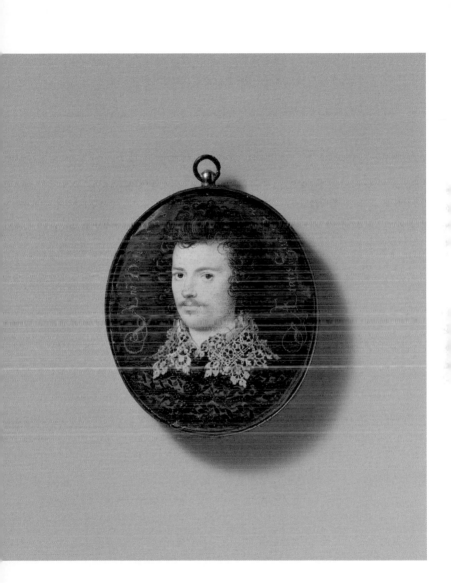

Portrait of a Young Man, 1588, Nicholas Hilliard,
vellum laid on card, 40 × 33 mm, Metropolitan Museum of Art

The Cholmondeley Ladies, c.1600–10

Two women, twice the mystery

If you commissioned a portrait in Jacobean times, true likeness would not be top of your list. You'd want something that defined your lineage, accolades and aspirations, ideally via arch symbols or puns. Try to find any visual clues here, however, and you encounter mostly dead ends. The breadcrumb trail is obscured; the sitters cut from context. But that is partly why the painting paws at you. That and its doubleness. It's hypnotic. The inscription says these 'Ladies of the Cholmondeley family', were 'born the same day, Married the same day And brought to Bed [gave birth] the same day', though unfortunately it isn't reliable, postdating the painting by more than a 100 years. Say it *is* true – were they sisters, twins, cousins, in-laws? Best scholarly guess is a Mary and Lettice Cholmondeley, born around 1580 – but it is just that, a guess. As for who painted it, for a long time folk memory attributed it to the artist behind the 'Ditchley' portrait of Elizabeth I, but that's since been disproven. Even if someone solved these mysteries, perhaps it's better not to know. Some paintings are important because of what they tell you, but this one is like the opening line of a story that could branch in any direction.

The Cholmondeley Ladies, *c.*1600–10, Unknown artist, oil on wood, 886 × 1732 mm, Tate

Lord John Stuart and his brother Lord Bernard Stuart, c.1638

A Baroque tribute to gilded youth

Every cardinal, queen and prince tried to snare Antoon van Dyck – or Anthony as we've lazily renamed him – as their court painter, but Charles I of England won, with the aid of a knighthood and a mansion. It was 1632 and Charles had just done away with parliament – he would rule alone, he said. Meanwhile, war abroad, religious tension at home and the creaky pomp of his court nudged his bloody fate a little closer. Both he and said court, though, were oblivious to all that, and so for almost a decade, Van Dyck's studio was crammed with a satin-clad whirl of aristocrats. Pictured here are Lords John and Bernard Stuart, youngest sons of the Duke of Lennox. Those spurs, that cloak, the silky hair – it's easy to see why van Dyck was so popular among the cavaliers, and how he incensed the Puritans. After the revolution, Oliver Cromwell made sure that *his* official portrait was plain and accurate, 'warts and all'. Yes, the Stuart boys have an air of entitlement about them but they were just teens, probably puffed up by the prospect of a life filled with opportunity and power. But was not to be: by 1645 both boys had been killed in the Civil War.

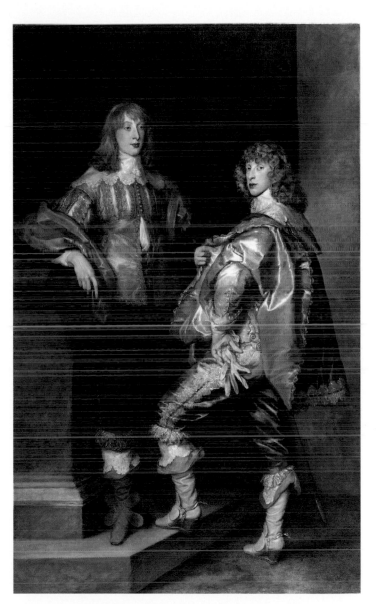

Lord John Stuart and his brother Lord Bernard Stuart, c.1638,
Anthony van Dyck, oil on canvas, 2375 × 1461 mm, The National Gallery

'Long View' of London, 1647

Soaring panorama from before the Great Fire

But for Wenceslaus Hollar, our grasp of 1600s London would be slight. In his etchings and drawings the city that was reduced to rubble by that century's Civil War and Great Fire returns to intoxicating life. Born a nobleman in Prague, Hollar came here aged 30 as engraver to the Earl of Arundel. London enthralled him. Off the clock, he sketched it compulsively (he was 'a very passionate man', noted a contemporary). Many of these drawings informed his *Long View*, a soaring, six-panel panorama that he pieced together from the tower of St Saviour in Southwark. Its detail is mouth-watering. Hollar manipulated his burin with dizzying range. In whiskery dashes and hatchings, he describes every roof tile, every street cobble, watermen on the Thames, strollers on the bank. These figures are millimetres tall and yet so tenderly done that you half expect them to move. If you could just get a little closer, you begin to think, you could see the buttons on this one's doublet, the bodkin in that one's hair. 'People sometimes say to me,' wrote the Victorian etcher and Hollar disciple Francis Seymour Hayden, '"What is it you see in Hollar?" and I always answer, "Not quite but nearly everything".'

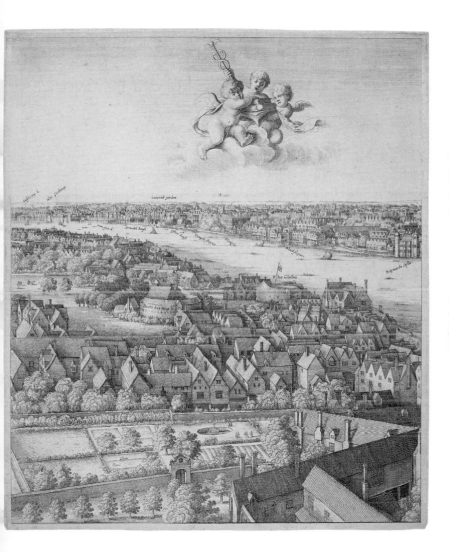

'Long View' of London, 1647, Wenceslaus Hollar, etching, 480×405 mm, Royal Collection Trust

Marriage A-la-Mode II – The Tête à Tête, c.1743

Two wastrels endure an arranged marriage

As a chronicler of London's absurdities – particularly its lacerating injustices and villainous self-interest – Hogarth has no rival. His paintings skewered the upper, lower and merchant classes in equal measure: corrupt electioneers, rakes happily squandering their family fortune at cards, beggar-women eager to swap their baby for a tot of gin. He is probably best known for his episodic, so-called 'modern moral subjects', in which various everyman and everywoman characters grapple with (and usually fail to survive) a social evil. This one concerns an arranged marriage between the son of the bankrupt (and excellently named) Earl Squanderfield, and the daughter of a rich but tight-fisted merchant. It isn't subtle: picture two of six and we've bypassed the marriage entirely (picture one was its negotiation). The viscount is already syphilitic, with something lacy in his pocket. He and his wife are bored and bleary, recovering from their separate pursuits. Their bill-laden steward rolls his eyes heavenward. Much of the gaggery is too pronounced for modern taste, but Hogarth's imagination is as impressive as it ever was. Wrinkled stockings, sheeny china, fire leaping in the grate. There is something here to amuse and absorb us in every single square inch.

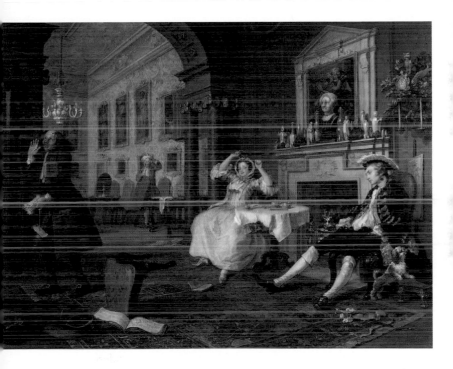

Marriage A-la-Mode: II – The Tête à Tête, c.1743, William Hogarth, oil on canvas, 699 × 908 mm, The National Gallery

Mr and Mrs Andrews, c.1750

Husband and wife flaunt the fat of their land

Robert Andrews – loafing here on his acres with wife, Frances – was a childhood friend of Gainsborough's. The boys went to school together, which may explain the puerile phallic scribble that the artist concealed in Frances's lap. No wonder the painting stayed untitled and hidden from public view until the 1920s, by which time all involved were long in the grave and we could be persuaded the scribble in question was a shot pheasant. When the portrait was painted, the two men were in their early twenties and Andrews – thanks to his carefully arranged marriage – had come into the 3,000 acres of prime Stour Valley land on which little Frances settles her satin mules. The painting is Gainsborough in the raw: much less fluffy, and less creakily sumptuous than the style he later adopted (the faster to fill his purse). It glows with his feeling for the land, too. He glories in the dip and rise of the hills, the shadows skimming and racing across the valley and the leaden sky. That said, the painting's celebration of ownership has made it cannon fodder for conversations about land rights. Like almost every other landscape of that era it ignores the reality of the Enclosure Acts, which were rapidly disenfranchising rural workers.

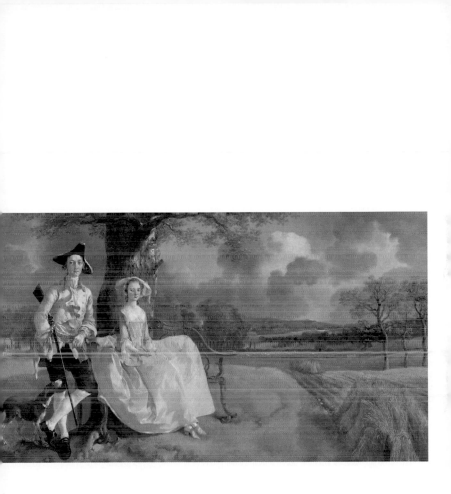

Mr and Mrs Andrews, *c*.1750, Thomas Gainsborough, oil on canvas, 698 × 1194 mm, The National Gallery

Whistlejacket, c.1762

Hyper-real portrait of a prize stallion

In the late 1700s England went wild for horses. Breeding them, racing them and especially betting on them. Entire fortunes were made and lost on a single punt. Whistlejacket was a favourite; famous for winning his owner, the second Marquess of Rockingham, £2,000 (over £300,000 today) in a single race. It was he who commissioned this muscle-rippler of a portrait. Traditionally only royals were awarded such a grandeur-bestowing scale. What's more, Stubbs scrutinised Whistlejacket in the manner his portraitist colleagues would a person. So discernible are the horse's features, in fact, that you'd recognise him in the stables, even if Whistlejacket didn't: a (probably apocryphal) story says he mistook the canvas for a rival and went for it. Stubbs – a teetotal workaholic – went to extreme lengths to achieve such verisimilitude. Holed up in a remote barn in Lincolnshire, he suspended horse carcasses from the ceiling, injected them with wax to slow decomposition and spent 18 months dissecting and drawing every slice. The painting's blank ground tormented his contemporaries, who couldn't fathom that it was intentional and so concluded it must be an unfinished portrait of George III.

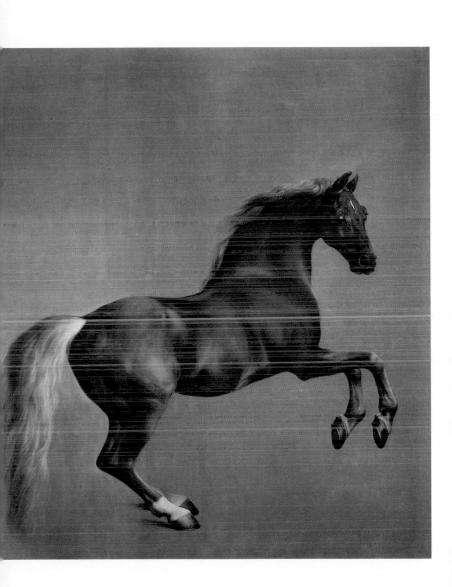

Whistlejacket, *c.*1762, George Stubbs, oil on canvas, 2961 × 2480 mm, The National Gallery

An Experiment on a Bird in the Air Pump, 1768

Scientific spectacle in the age of wonder

Not for the squeamish, this painting captures the excitement of public demonstrations in the time of the scientific revolution and the Enlightenment. The figure in the middle here is modelled on James Ferguson, a self-taught astronomer, scientific instrument maker and author who began life as a shepherd boy. Wright had seen him conduct such experiments in Derby. The experiment is real too, designed to demonstrate a vacuum, though it wouldn't have featured a cockatiel – they were incredibly rare and despite the experiment being carefully timed, the bird frequently suffocated. In the painting, Wright captures this knife-edge moment: will the demonstrator let air back into the glass in time? Such jurisdiction gives him god-like powers. If there is any god here, though, it is Wright, with his precise deployment of – and infectious delight in – the forces of light and shadow. Moon gleam and candle glow anoint the scene, burrowing into cloth folds and brow creases. Beyond the rapt faces of the watchers, though, creeps a deep, engulfing darkness. Was Wright a spokesman for, or sceptical about science's ambitions? The demonstrator is looking at us for an answer. Meanwhile, the pocket watch at the front is ticking, time is passing, and life hangs in the balance.

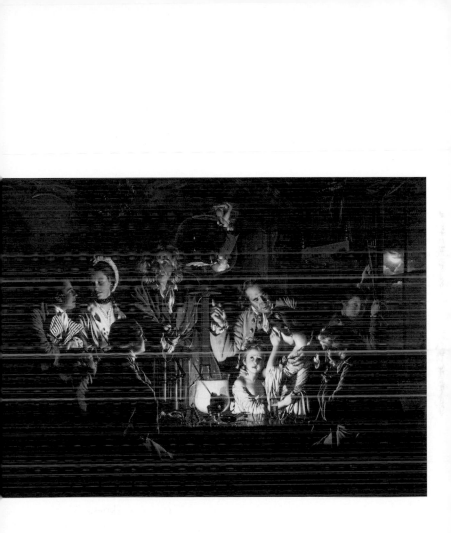

An Experiment on a Bird in the Air Pump, 1768, Joseph Wright 'of Derby', oil on canvas, 1829 × 2439 mm, The National Gallery

Llyn-y-Cau, Cader Idris, c.1774

Rugged Welsh landscape by a pioneering painter

He died in poverty and a slave to drink, but in his heyday, Richard Wilson ran teeming studios in Rome and Covent Garden, visited by wealthy patrons. He was a landscapist bar none – known as the 'English Claude', which must have irked him no end, being Welsh. Actually, Wales was à la mode then: its druidic past a hot topic in London's coffee houses. Even so, it had no art school or likely collectors, which is how Wilson ended up in Italy, supping on classical remains and the work of celebrated landscapists like Poussin, Zuccarelli and – yep – Claude. What happened next is magical, because Wilson took their lacquered, dispassionate 'Grand Style' and began applying it to remote parts of Britain, such as in this airy rendering of mountains in northern Wales. Into these paintings he poured emotional engagement, plus close observation of light and weather – gained, heretically, *en plein air*. His paintings were a huge influence on Constable. Turner and Gainsborough too. In fact, without Wilson, the revolution they instigated might never have happened.

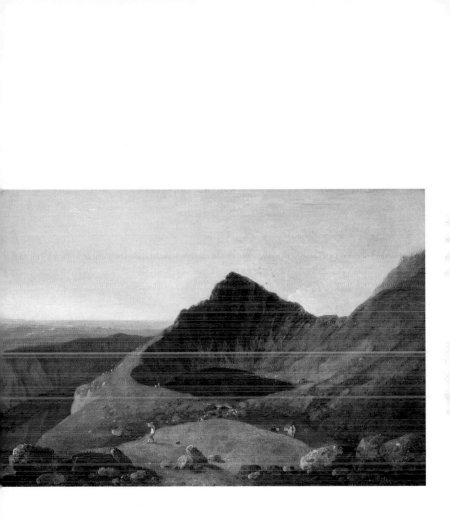

Llyn-y-Cau, Cader Idris, *c.*1774, Richard Wilson, oil on canvas, 511×730 mm, Tate

The Ladies Waldegrave, 1780

'Shop window' portrait with a sting in its tail

Collector Horace Walpole used the word 'gloomth' to describe the gothic ambience of his eccentric Thames-side villa, Strawberry Hill. Imagine, then, how the milky skin, powdered hair and muslin dresses in this painting of his great-nieces – the Ladies Elizabeth, Charlotte and Anna – would have glowed from its nook in the house's Great Parlour. Reynolds was an exceptional portraitist, a genius of 'spin' with a knack for sophisticated compositions and graceful gestures. By 1780, he was as much of a celebrity as the aristocrats, philosophers, courtesans and actors who queued up to be painted by him: the founding president of the Royal Academy, no less, where his *Discourses on Art* dictated the prevailing style of British art. Apparently, he was much more playful away from the lectern – as is perhaps in evidence here. Because while at first glance, Elizabeth, Charlotte and Anna resemble the three graces (a popular motif at the time) their pastime – winding silk thread and lace – has more in common with the three fates, an infinitely more powerful and deadly trio, who spun (and could cut) the thread of life. Was Reynolds inciting the girls to assertiveness? Perhaps he was sick of these 'shop window' portraits of marriageable girls, even if no suitor seems to have noticed: Elizabeth married an Earl, Charlotte a Duke and Anna an Admiral.

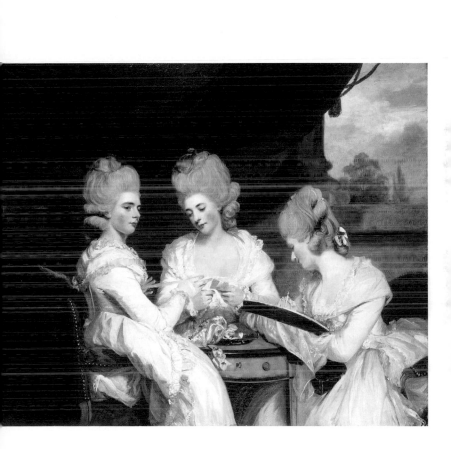

The Ladies Waldegrave, 1780, Joshua Reynolds, oil on canvas,
1430 × 1683 mm, National Galleries of Scotland

Fashionable Contrasts, 1792

Wicked take-down by our national lampooner

Satire blooms in times of turbulence, and Georgian times were nothing if not turbulent. Gillray was its don – dubbed the 'Prince of Caricatura' by one contemporary. From 1775 to 1811 he produced over a thousand dazzling prints. Cross, capering 'Little Boney', as Gillray imagined Napoleon, often got it in the neck (once exiled to Elba, he said that Gillray had done more than all the armies of Europe to bring him down). But the royal family were his chief prey: hapless, miserly King George III, dull Queen Charlotte, the debauched, waistcoat-busting Prince of Wales and, as here, the hopelessly mismatched Duke and Duchess of York. Frederica Charlotte, Princess of Prussia, married George III's second son, Frederick, in 1791. A royal wedding, then as now, was a banquet for the press, and the morsel the pressmen chose to feast on was the lady's 'smallness of foot'. Tiny feet were immediately a must-have, and women country-wide began torturing their arches into small shoes. To Gillray, such idiocy was too good to ignore. He made several engravings on the topic, but this one is the very best. Its wickedness (it takes a second to clock the implication) is genius, matched only by Gillray's artistry.

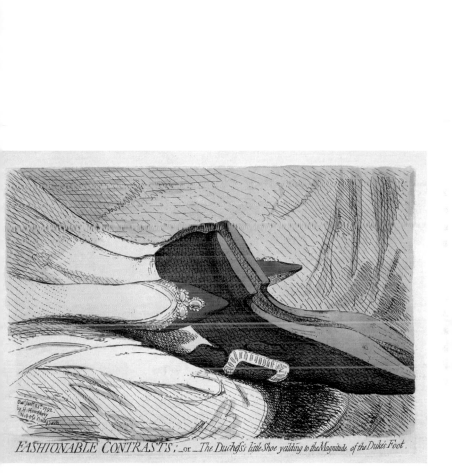

Fashionable Contrasts, or The Duchess's little Shoe yielding to the Magnitude of the Duke's Foot,
1792, James Gillray, etching with watercolour, 250 × 350 mm, Private collection

Newton, c.1795–1805

A visionary's attack on science

Blake loathed Isaac Newton and all he stood for. He called science the 'Tree of Death,' and denounced the great mathematician and discoverer of gravity in quite a few poems and paintings, here most flagrantly. The painting is a sort of visual scoff – Newton so hunched over his calculations and so spellbound by them that he is blind to the delicate, zingy beauty of the coral and algae around him. Newton's ideas concerning 'opticks', or the science of sight, were especially offensive to Blake. Not least because Blake was a seer, blessed with burning spiritual visions. He saw his first angels when he was ten, and spent much of his adult life conversing with, and sketching, the deities and demons who visited his humble lodgings in Lambeth. Paintings like *Newton* (later the prototype for Eduardo Paolozzi's bronze colossus outside the British Library) were part of Blake's mission – as he saw it – to release the masses from cold, rigid reason into imagination's limber joys. It was the masses' duty to listen and agree, too, and Blake was baffled when they didn't. 'Shall I call him Artist or Genius – or Mystic – or Madman?' wrote the diarist and Blake's friend, Henry Crabb Robinson. 'Probably he is all.'

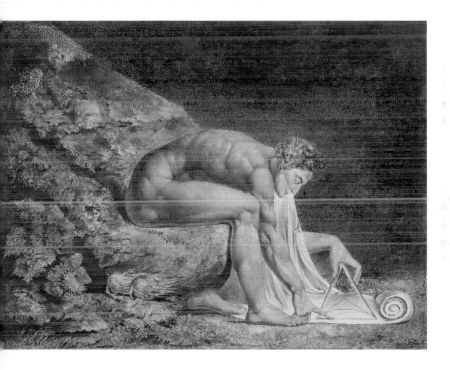

Newton, *c.*1795–1805, William Blake, colour print, ink and watercolour on paper, 460 × 600 mm, Tate

The Hay Wain, 1821

Everlasting summer on the River Stour

Poor Constable. The ubiquity of *The Hay Wain* has made it too easy to be blasé about it. Death by a thousand biscuit tins. Even so, it's hard to think of a painting that so defines our radiant countryside – and the capriciousness of a British summer's day. Fellow Romantic artist Fuseli once joked that Constable's work made him reach for an umbrella. Screw up your eyes a bit and you can smell the moss, hear the cartwheel creaking, the shinnnnggg of scythes being sharpened in the far field and Constable scratching away at his easel. For such a potently British painting – it recently starred in conversations about climate change and oil when protestors glued themselves to its frame – it's odd that British gallery-goers as good as ignored it, until a shrewd Frenchman took it to the 1824 Paris Salon. And thank goodness, because it inspired the next generation of artists to take that all-important leap towards painting landscapes outside in the open air.

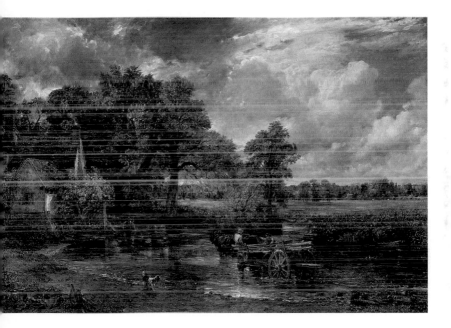

The Hay Wain, 1821, John Constable, oil on canvas, 1302 × 1854 mm, The National Gallery

The Weald of Kent, c.1827–8

Landscape with divinity in every leaf

Palmer's early paintings have a hallucinatory, slumbery quality. He once said that he felt as if he had been blessed with the powers of spiritual vision, which perhaps explains it. *The Weald of Kent* was painted near Shoreham, where the twenty-something Palmer and his middle-class London friends decamped to form The Ancients, a group of artists united in admiration for William Blake (p.36) and their intent to leave the modern world behind. Palmer's Shoreham paintings are joyously strange: lathery hedgerows you could plunge your hands into, blossoms that seem as if they appeared all at once. Here, a 'repoussoir' of trees gives the land beyond the feel of a faerie kingdom, as if spied through a tunnel or hollow-way. The paintings were not palatable to the artistic establishment, but Palmer knew that. He locked them away in his so-called 'curiosity portfolio', where they languished until the modernists fell in love with them in the 1920s. A generation later, they also attracted the attention of the infamous Tom Keating, who confessed to forging 13 in 1976, though experts think the number nearer to 20. They're now as collectible, if not as pricey, as Palmer's originals.

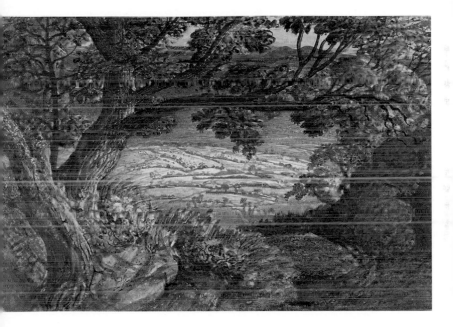

*The Weald of Kent, c.*1827–8, Samuel Palmer, watercolour and
gouache on paper, 187 × 270 mm, Yale Center for British Art

Eos, 1841

Price Albert's favourite creature (apart from Victoria)

In his day, Landseer was a phenomenon – a wunderkind who exhibited at the Royal Academy at the tender age of 14, plus a darling of Queen Victoria. But tastes have changed and today his sentimental, often anthropomorphic take on the kingdom Animalia can feel painfully schlocky to modern eyes. With, perhaps, one exception, in which whether by fluke or – who knows, a stab of rebellion – Landseer chose to paint a greyhound as a greyhound. Eos – the greyhound – was Prince Albert's special companion, and the Queen commissioned the portrait as a Christmas present. She was as smitten with dogs as he: their menagerie included collies, deerhounds, other greyhounds, terriers, Mastiffs and, at one time, a cool 35 Pomeranians. The painting, with its top hat, ivory cane and deerskin footstool, is beyond Victorian. But it's also beautifully lit and beautifully observed. The Prince hung it in his dressing room at Buckingham Palace, and it must have been a daily comfort when, two and a half years later, Eos died. 'Poor dear Albert,' the Queen wrote in her journal, 'He feels it terribly.'

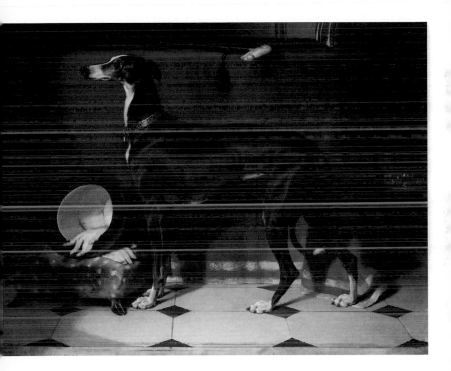

Eos, 1841, Edwin Landseer, oil on canvas, 1118 × 1429 mm, Royal Collection Trust

Rain, Steam, and Speed – The Great Western Railway, 1844

The thrill and danger of the modern world

A train rushes across a bridge in lashing rain and a halo of fiery light. So what? By 1844 the sight wasn't uncommon – railroads had been chewing their way through the countryside for 15 years – but Turner's treatment of it was. Instead of telling us what he saw, Turner opted for a kind of phantasmagorical blizzard that conveys what it felt and sounded like to be on that spot, in that particular moment. If you look (very) closely you'll note the train is closing in on a faint lick of a hare, though really, there's nowhere for him to run. Might that, and the tiny horse-drawn plough near the painting's right edge, make it a sermon of sorts – technology the nemesis of the natural world, intent on its destruction? I don't think so. On the evidence of other paintings and sketches at least, Turner loved the dirty skies and belching soot of the Industrial Revolution – perhaps because his life coincided almost exactly with its trajectory. Besides, look at the way he painted the passing cloudscape above the train and the pulses of light flitting through it. It's beautiful.

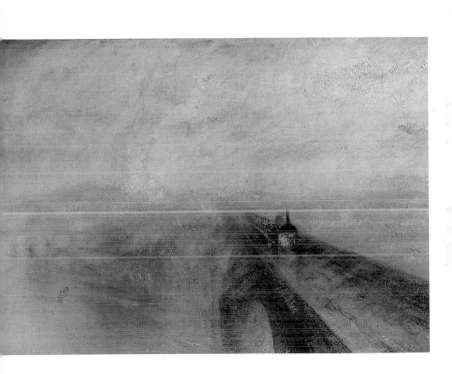

Rain, Steam, and Speed – The Great Western Railway, 1844, Joseph
Mallord William Turner, oil on canvas, 910 × 1218 mm, The National Gallery

Nocturne in Black and Gold, The Falling Rocket, 1875

An evening painted from memory

American by birth, Whistler lived in London most of his life and his paintings of the city are among its most sensitive portraits. You see it best in his pictures of the Thames – his odes to the working river at Limehouse and Wapping, or night-time scenes near his Chelsea home. Whistler made about 30 of these *'Nocturnes'* (he hoped the association with Chopin's music would help viewers understand that his smudged colour and soft shapes were not meant to be representational). He painted them from memory. Two brothers from a local boatyard would row him to the middle of the river in the thick of night and wait while he imprinted the view on his memory. The following day, he'd recreate the half-remembered scene, using thinned paint he called 'sauce'. It sloshed and pooled to such a degree that the canvas had to be flat on the floor to prevent the colour from running. The *Nocturnes* made him enemies – most famously Ruskin, whom Whistler sued for libel when the critic called him a 'coxcomb' (vain) and this painting an impudence akin to 'flinging a pot of paint in the public's face'. Today, though, they are considered a milestone in the evolution of modern, abstract art.

Nocturne in Black and Gold, The Falling Rocket, 1875, James Abbott
McNeill Whistler, oil on panel, 602 × 467 mm, Detroit Institute of Arts

Proserpine, 1877

Tribute to a woman trapped in a marriage

Think of Pre-Raphaelite painting and undoubtedly a woman with flaming hair, pillowy lips and a faraway look in her eye will undoubtedly glide into your mind. We know the look of these 'stunners' – as Rossetti and co. cringingly referred to their models – arguably better than any other women in art history. The Pre-Raphaelites were bound by admiration for medieval art. They were bound in other ways too: as models, as in-laws and as rivals in love. Their best pieces display this – particularly Proserpine here, a painting Rossetti referred to as his 'very favourite design' (he returned to it over and over again, painting eight different versions). It's based on the Roman myth in which the eponymous heroine is kidnapped by the god of the underworld and condemned to be his unwilling bride. The subject was suggested by William Morris, whose wife Jane was its model – and Rossetti's lover. Her sad face, dark eyes and mass of crinkly hair animate many of his paintings. As a woman trapped in an unhappy marriage (Morris was famously tricky to live with) Proserpine's predicament reflected Jane's own – certainly in Rossetti's lovelorn eyes. Lovelorn, but still discerning. Pre-Raphaelite portraits often suffocate from being overworked, but here the artifice works – Proserpine shining, as if trapped behind glass.

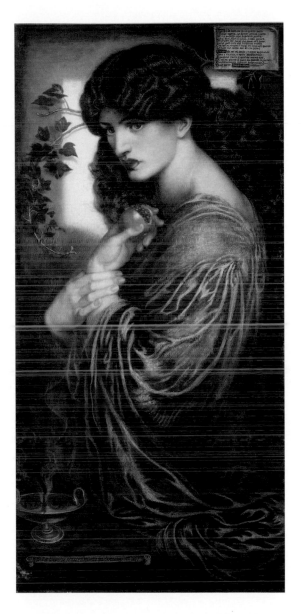

Proserpine, 1877, Dante Gabriel Rossetti, oil on canvas, 1251 × 610 mm, Private collection

Carnation, Lily, Lily, Rose, 1885–6

Impressionism in the Cotswolds

Carnation, Lily, Lily, Rose was painted at an expat American artists' colony in the Cotswolds. Sargent was there in the care of friends, waiting out the scandal that his portrait of 'Madame X' and her lavender-powdered decolletage had caused at the Paris Salon. It was inspired by an evening boat trip on which Sargent glimpsed children lighting paper lanterns on the banks. He'd recently returned from Giverny, where he had painted alongside Monet in the garden and was eager to implement the impressionist's now fashionable *en plein air* technique. Switching styles was the easy bit. Capturing the mauvish twilight glow, less so. 'Impossible colours,' he wrote, 'Paints are not bright enough and then the effect only lasts 10 minutes.' He settled on a system whereby he'd set up the scene, wait until the light was right, then gallop over the lawn to paint in rapid dabs. The children are Dolly (left) and Polly Barnard. Their mother and her sister made the dresses specially, in the style of Kate Greenaway's popular children's book illustrations. The girls quickly tired of their role, but Sargent kept sweets in his pocket to console them for losing their last hour of play before bedtime.

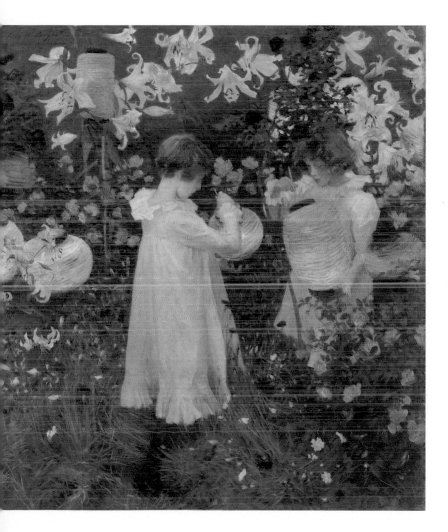

Carnation, Lily, Lily, Rose, 1885–6, John Singer Sargent, oil on canvas, 1740×1537 mm, Tate

Flaming June, 1895

Once thought worthless, now a cherished masterpiece

Sleeping (see also: drowned, enchanted) women were a stock-in-trade for the Aesthetic and Pre-Raphaelite movements. Leighton didn't quite slot into either, but he was taken with the motif and explored it in several paintings, of which this is the most famous. He claimed it was spur of the moment, the lucky outcome of 'a weary model with a [very!] supple figure' who had curled up to nap on his studio chair, though the stash of related sketches and studies of drapery, colour and nudes in his archive suggests otherwise. He was fatally ill when he painted it, so perhaps had one eye on *Flaming June*'s future – weaving her a tantalising creation myth. He needn't have, because she made one of her own, a life story quite as colourful as her canvas. Following a stint in the Ashmolean, the picture disappeared for 30 years, before being rediscovered behind a false panel in a house in Clapham. One charity shop and an eagle-eyed dealer later, it ended up in the Museo de Arte de Ponce in Puerto Rico. In her new home, she's a superstar, known as 'the Mona Lisa of the Southern Hemisphere'.

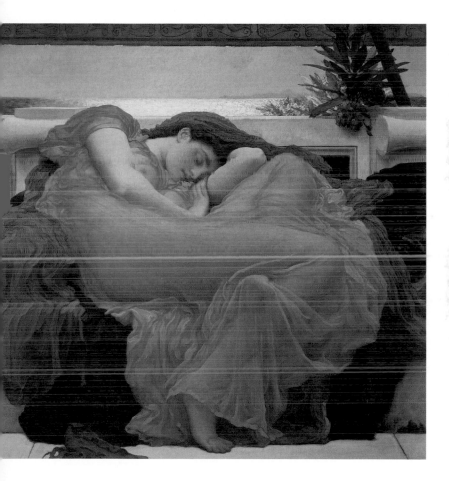

Flaming June, 1895, Frederic Leighton, oil on canvas, 1191 × 1191 mm, Museo de Arte de Ponce

Gallery of the Old Bedford, c.1895

Strange world where dream and reality tangle

To us they seem quaint, but in Sickert's day music halls were ragingly modern. For a time, Britain was wild for them – in 1888 Parliament recorded 473 in London alone. Initially the preserve of the working classes, they quickly attracted the attention of the bohemian set. Sickert went 'nightly', and once sent a telegram home from the stalls to inform his wife and guests that he would not, after all, be back for dinner. He took little cash books and postcards in his pockets to sketch the goings-on, annotated with lines from the comic ditties that drew in the crowds. Back in his studio, he turned them into expressive paintings that render beautifully what he called 'the solid basis of beef and beer ... the whiff of leather and stout from the swing-doors.' Sickert preferred music halls where the stage was closer to the audience and the atmosphere less formal. A particular favourite was the Bedford in Camden. Its three-tiered auditorium – all smoky mirrors and gilt moulding – inspired him to try immersive, radical pictures, which concentrate solely on the audience. Even now, you can almost hear the warbled ditties floating over the murmur of the crowd.

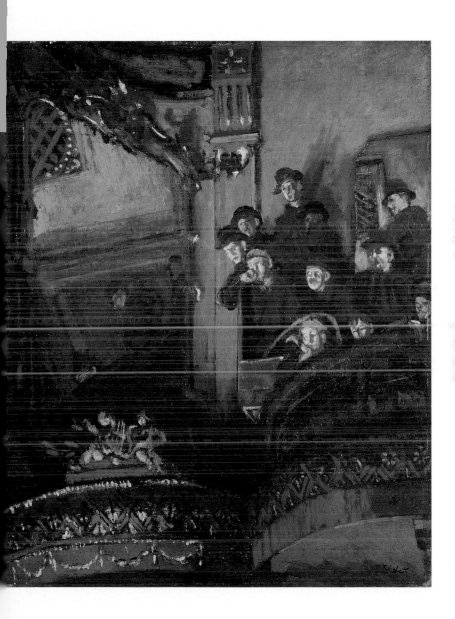

Gallery of the Old Bedford, c.1895, Walter Richard Sickert, oil on canvas, 763 × 605 mm, Walker Art Gallery

Self-Portrait, 1902

Portrait of the artist as a modern girl

Gwen John was 26 when she painted this Jane Eyre-like self-portrait. Every inch the repressed, brooch-wearing Victorian, you'd think, though she'd already fought her father to study at the Slade and spent a year in Montparnasse. Once you know that, the whole tone of the painting changes – her measured gaze the sign of spirited single-mindedness. She hasn't quite cut loose, but she's on the cusp of it. Behind that composed countenance there's a world of something trying to get out. It soon did. The following year, she and her friend Dorelia decided to walk to Rome, sleeping in fields and paying their way by singing and selling portrait drawings. They gave up at Toulouse whereupon John moved to Paris, supporting herself by becoming an artist's model, famously for Rodin. Her friendship with the sculptor, 64 to her 28, developed into a painful love affair. She wrote him more than a thousand letters – sometimes three times in a day. 'Love is my illness,' she wrote, 'and there is no cure till you come.' It's this paradox that makes her paintings captivating. Delicately toned, muffled by the ground chalk used to stiffen her paint, they are so completely remote from her passionate reality.

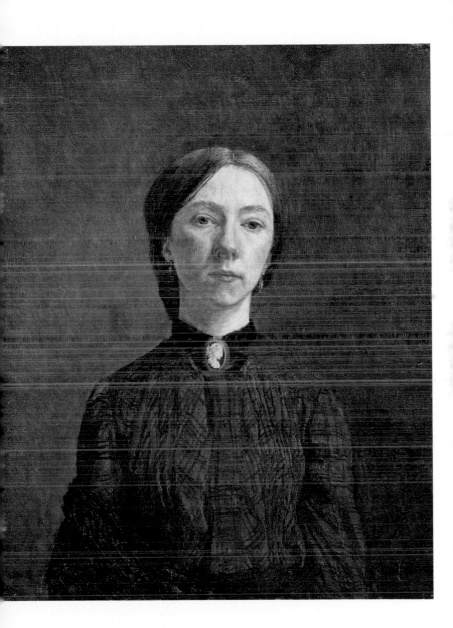

Self-Portrait, 1902, Gwen John, oil on canvas, 448 × 349 mm, Tate

The Lustre Bowl with Green Peas, 1911

A study in light by a virtuoso

In his lifetime William Nicholson was a sought-after society portraitist, but he drifted from view afterwards, eclipsed by his son Ben (p.96), whose abstract work catalysed British modernism. William was not swayed by that tide or any other 'ism' of his era: he was a resolute lone ranger. Lately though, he has accrued a long-overdue following – only this time around it's the still lifes and landscapes he made for his own pleasure, instead of his bread-and-butter work. This plump-bellied, shiny silver bowl here is the best, painted at his country house in Rottingdean away from the confines of London society. He first attempted still life painting in 1908 – tradition has it, for a bet – masterfully capturing the textures of different surfaces in his pieces. From then on, shiny items figured regularly in his work, encouraged by his collecting vernacular pottery. His instinct for organising the canvas is also exquisite: the pronounced shadow, the flare of sunlight on the bowl's rim, the reflection on its underside, that zingy green. And all of it flushed with Nicholson's presence. He's here in the room with you, in a way he isn't always elsewhere.

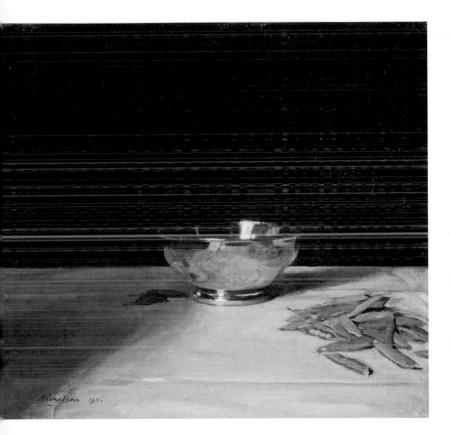

The Lustre Bowl with Green Peas, 1911, William Nicholson,
oil on canvas, 550 × 600 mm, National Galleries of Scotland

The Cornish Coast, 1917

A breezy, sun-soaked depiction of Britain's coast

This salt-bright painting of two women beside the sea is one of many that Knight made in and overlooking the Cornish coastline near Penzance. If you could follow the blonde-haired woman's line of sight, you'd be looking out across the steel-blue water of Lamorna Cove toward the rugged headland of Carn Du. Knight, who was the first woman to be elected a Royal Academician, moved to Cornwall in 1907 and stayed there throughout the First World War. For that reason, the paintings she created there feature mainly women and children, most men being away at the front. Every day, her dog Tip in tow, Knight walked the steep footpath from her house in Lamorna along the cliff edge. To capture seaside life, or the effects of sun and shadow on water, she kept sketchbooks in her cardigan pockets. Further afield, at Carn Barges and Porthcurno, she'd paint while sitting in the back of her old Rolls-Royce, with its door thrown wide open. The two women in the painting are probably local girls Phyllis Vipond-Crocker and Marjorie Taylor, who often posed for Knight. They're almost always faceless – the coast, the sea is the thing.

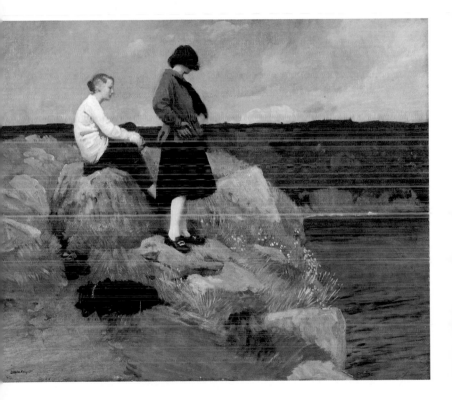

The Cornish Coast, 1917, Laura Knight, oil on canvas, 648×763 mm, National Museum Wales

Over the Top, 1918

The tragedy of war unfolding in slow motion

Many argue for his brother Paul, but just as many believe the younger John, who had no formal training as an artist, is the better painter. A self-described 'artist-plantsman' who delighted in horticulture, Nash junior took up painting on his brother's advice, and had his first exhibition shortly before the First World War. He served in the 1st Artists' Rifles. *Over the Top* commemorates a disastrous counter-attack at Marcoing in December 1917, in which almost all his comrades were killed. 'It was bitterly cold and we were easy targets against the snow,' wrote Nash, the action 'pure murder … we didn't stand a chance.' The painting is magnificent – a tragedy unfolding in slow motion, the advancing men a mirror of Brueghel's faceless hunters in the snow, though here they are prey, and the landscape they are trudging into is one of yellow gas instead of teeming life. Nash worked on it in an old herb drying shed in Buckinghamshire, his easel a few feet from where Paul was working on his war painting, *The Menin Road* (1919). Come evening, though, both went outside to paint the last scatterings of sunlight on the surrounding hills, 'in sheer relief', said John, 'at being still alive and back in the English countryside.'

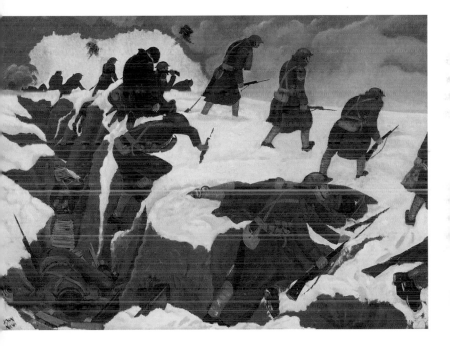

Over the Top, 1918, John Nash, oil on canvas, 798 × 1080 mm, Imperial War Museum

VANESSA BELL

Interior with Duncan Grant, 1934

A time capsule of Bloomsbury chic

Paintings of light-washed domestic interiors were a great favourite of British modernists. Not the impersonal, status-oriented backdrops of Victorian and Edwardian art, but warm, lived-in rooms bearing the owner's imprint. Here, Bell spins the concept into something both covetable and still intensely relatable. It pictures her romantic partner, the painter Duncan Grant, in a sitting room at Charleston, the modest but magical Sussex farmhouse to which they moved in 1916 with Grant's other lover, David 'Bunny' Garnett. Both artists chronicled their household, which became a focal point for the baggy circle of avant-garde artists and writers known as the Bloomsbury Group. Their paintings preserve the genius loci of the place: picture to picture, the impression builds, of a quiet but soul-warming life lived by persons deeply interested in one another, and in new ways of being. Bell's recreation of the setting here is so vivid that we can imagine the sound of Grant turning the pages of his book, or leaves rustling through the window on his left – and look how those same leaves make the light ripple on the green wall. It's as if Bell has left a door open, through which we can temporarily step.

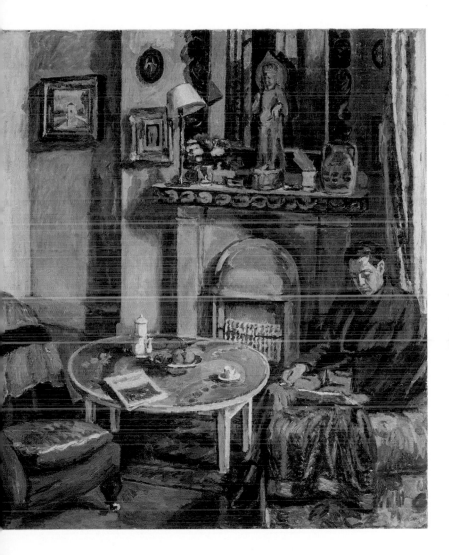

Interior with Duncan Grant, 1934, Vanessa Bell, oil on canvas, 1122 × 973 mm, Williamson Art Gallery

Lap Full of Windfalls, 1935

A celebration of rural rhythms

In the early 1930s, concerned that the Great Depression and mechanisation were destroying the bucolic life of the countryside, Leighton began two series of wood engravings that would preserve it for future generations. It was a good time to be a wood engraver (the modernists admired all that was handmade) but an even better time to be making work about nature. Gloomy headlines about unemployment and fascism had set people everywhere the way of rambling or gardening. Leighton's engravings turned into two books: *The Farmer's Year* (1933), which treasures the rhythms – and the back-breaking toil – of agricultural labour, and *Four Hedges* (1935), about her year creating a garden in the Chilterns. This engraving, *Lap Full of Windfalls*, is from the latter. Both books are so zesty, conjuring in mere lines, specks and dashes the light falling on the hayricks, an apron's swish, the craft in threshing and lopping. The pictures are girdled by text that's just as attentive: 'Gold falls in splashes on the branches of the elm,' she writes, or, 'Here in this soft land of shelter … rise the little wooded hills.'

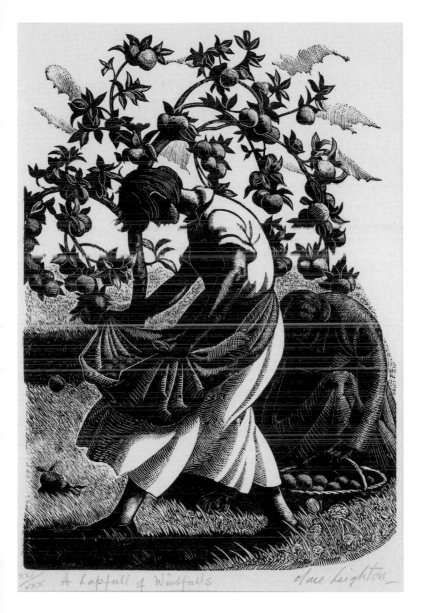

XXI/XXX A Lapfull of Windfalls Clare Leighton

Lap Full of Windfalls, 1935, Clare Leighton, wood engraving, 174 × 121 mm, The Mint Museum

Portrait of Stephen Spender, 1938

How paint can convey the presence of a poet

Not long after he was expelled from the Slade for being insolent, Wyndham Lewis turned himself into a luminary. Walter Sickert (p.68) thought him 'the greatest artist of this or any other time', which as blurbs go is quite something. He's best known as the leader of Vorticism, a flash-in-the-pan, avant-garde art movement that stood for, among other things, 'the Reality of the Present' and lighthouses, but against French aperitifs and 'the purgatory of Putney'. Still, they were the first in Europe to produce completely abstract paintings, their jagged style rooted in Cubism and Futurism, though Lewis pilloried both. Indeed, he was disputatious to a fault (at one time he went all in for Hitler, though swiftly recanted). A dunderhead move really, given he was dependent on the people he quarrelled with for work. The few people he didn't insult – at least, not irretrievably – he painted beautifully. T.S. Eliot most famously, but here, fellow poet Stephen Spender. Lewis worshipped Andrea Mantegna, and the Renaissance master's linear sharpness is much in evidence – a precisely moulded ledger of brow, philtrum, surging hair and forefinger. Lewis wanted his portraits to make you feel as if you're 'sharing a moment of life removed by centuries from your lifetime', and that is what he captures here. The electricity snapping away in Spender's brain; a genius deep in thought.

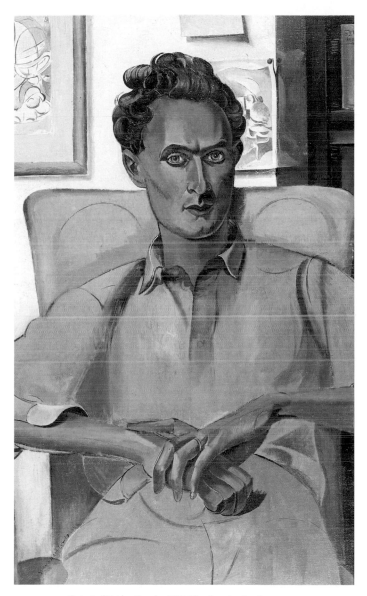

Portrait of Stephen Spender, 1938, Wyndham Lewis, oil on canvas,
990 × 580 mm, The Potteries Museum and Art Gallery

Cuckmere Haven, 1939

Light and wind in Sussex

'I like definite shapes,' Ravilious once wrote, and what a case in point – the river here almost surreal in its wide, bright loop. The whole landscape looks imaginary – straight from the pages of a children's story book. But it's real: Cuckmere Haven in Sussex, and Ravilious has captured beautifully the sinkings and swellings of the South Downs. Ravilious grew up in nearby Eastbourne, and returned to the area in the 1930s to weekend with his friend the painter Peggy Angus in her dilapidated cottage. The visit coincided with an artistic epiphany, as he abandoned the wood engravings he was then known for, in favour of watercolour. You can see how he carried over to his new pursuit the same marks he used in his engraving. With hindsight, it's hard not to read the imminent war into the picture. Cuckmere was an obvious weak point on the south coast and within weeks of this painting being completed a system of pillboxes and barbed wire had been installed in the valley. Most eerie though is that vault of grey sky, fading into nothingness. In 1942, a plane Ravilious was on in his capacity as Official War Artist disappeared off the coast of Iceland. His body has never been recovered.

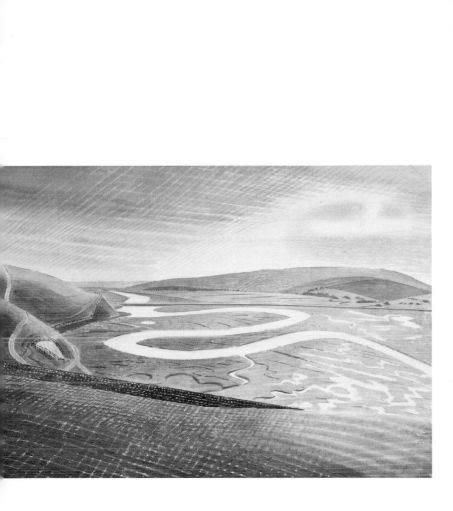

Cuckmere Haven, 1939, Eric Ravilious, pencil and watercolour on paper, 414 × 575 mm, Towner Art Gallery

Summer, 1940

Dusk in the Derbyshire hills

This radiant, unforgettable painting depicts the end of a hot summer's day, as the blue-mauve light of early evening steals across the land. The hedgerows are thick; the trees are in full leaf and, in the foreground, hay is being collected. You can almost smell it. The setting is unrecorded, though it is probably Derbyshire, where Allen spent a great deal of time after the First World War, having gained a military medal for Conspicuous Gallantry – although he saved an officers' life, he also lost a leg. Upon his return, he painted many views of the region. Pre-war, Allen's style was much more realistic, but by the 1930s he had perfected this amazingly sculptural, almost surreal technique, and was exhibiting at the Royal Academy. Hard to choose between this painting and his one of dry stone walls undulating through the Derbyshire hills, but the light here just pips it.

Summer, 1940, Harry Epworth Allen, tempera on canvas, 504 × 608 mm, Glynn Vivian Art Gallery

Men Stooking and Girls Learning to Stook, 1940

Land Girls learning traditional skills

Not so long ago, 'stooks' – sheaves of cut grain stacked in fields to dry during harvest – were a common sight in Britain, their style varying from county to county, according to ancient custom. The painting here is probably Hampshire, where Dunbar was sent in 1940 by the War Artists Advisory Committee to document the training of recruits to the recently reformed Women's Land Army. Pre-war, Dunbar had studied at the Royal College of Art and run a small gallery in Rochester showing work by inventive contemporaries like Barnett Freedman. Her own paintings were mostly horticultural or agricultural in theme. Stooking – such a pungently medieval word – was hard work: dusty and sweaty in August's belting heat, the sheaves unwieldy and stinking come September's rain. Dunbar conveys this in the girls' tense stance, and the way the chore stretches ahead of them, seemingly without end. But overall, the painting feels buoyant. Its geometry (she loved diagonals) and perspective (those Disney-like plaster-pink and mint stripes, the field bouncing into infinity) vibrant and spirited. Many women found their war work the most fulfilling episode of their lives, perhaps Dunbar wanted to convey that.

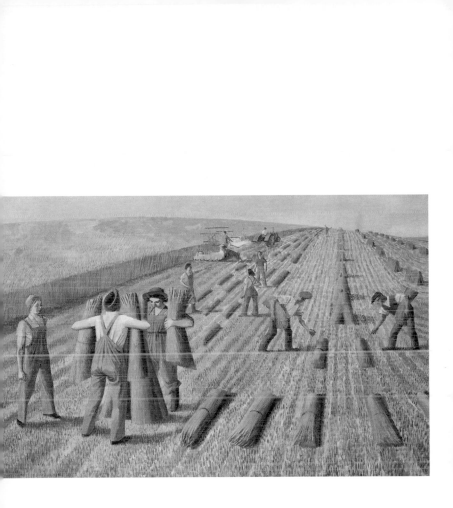

Men Stooking and Girls Learning to Stook, 1940, Evelyn Dunbar,
oil on canvas, 490×750 mm, Private collection

Jacob and the Angel, 1940–41

Jacob's all-night struggle with an unknown assailant

Today it's in the Tate – rightly revered for its radical modernity – but *Jacob and the Angel* spent its early life as a curiosity on Blackpool's Golden Mile, installed in an old song booth and advertised as for 'Adults Only'. We might jeer at such philistinism, but the impresarios of the promenade exhibited Epstein's work when museums would not, bringing a sensational showmanship to the display of modern art that has never really gone away. Hundreds of thousands paid to see it. Critics were undecided – 'Is this a miracle or a monstrosity?' asked the *Daily Mail* – but the uneasiness the sculpture provokes is precisely its power. Everything about it is designed to overwhelm, from its blocky heft to its viscera-like colours. Its confusing, near-carnal embrace. Truth is, *Jacob* didn't stand a chance. Epstein was already well into what he called his 'Thirty Years War' with the British public – his progressive ideas thought an affront to morality. It's rather sad, then, that only shortly after Epstein's death, *Jacob* was thought moderate enough to be loaned to Liverpool Cathedral.

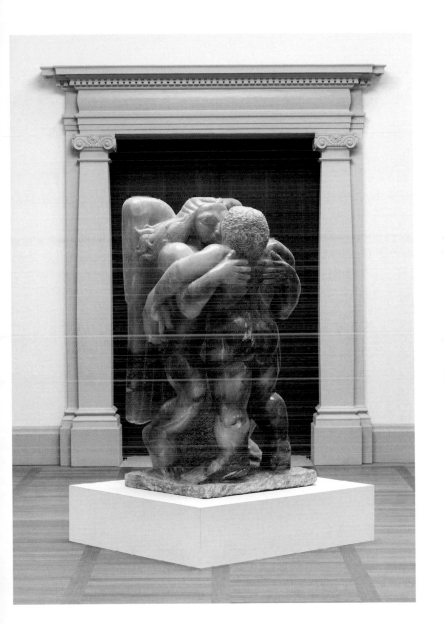

Jacob and the Angel, 1940–1, Jacob Epstein, alabaster, 2140 × 1100 × 920 mm, Tate

Oval Sculpture (No. 2), 1943

A form that embraces light and absence

'When I first pierced a shape, I thought it was a miracle,' said Hepworth of her 1931 artistic breakthrough. 'A new vision was opened.' From then, she carved or chiselled holes into almost all of her sculptures, as if in search of the vital anatomy of each piece of stone or wood. She described the process beautifully, as 'a kind of persuasion'. The egg-shaped piece here is one of her finest, an exceptional weave of space, shadow, material and light. Pierced in not one but four places, it evolved from exploratory drawings Hepworth had made the previous year; the intricacies of its interior wonderfully like the chambers and cords of a heart. The version here is a plaster cast that Hepworth made in 1958, after the plane wood original that she carved soon after she moved to a house overlooking the sea in Cornwall, began to split. Cornwall's craggy coastline was a profound influence on her work, as were the hills of her native Yorkshire, its 'textures, the forms and the sense of movement all belong to my sculptor's world,' she said. She had made work with spheres before, but ovals were new. For Hepworth, their rounded forms expressed the 'feeling of the embrace of living things'.

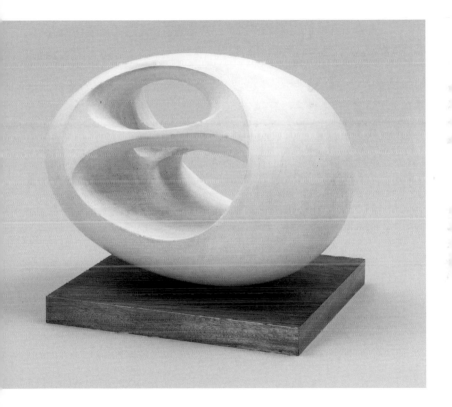

Oval Sculpture (No. 2), 1943, Barbara Hepworth, plaster on wooden base, 293 × 400 × 255 mm, Tate

L.S. LOWRY

July, the Seaside, 1943

Vision of an artist who stands apart from the crowd

Lowry was 52 when he was discovered by a London art dealer and given his first exhibition. By the time he was 81 he had turned down an OBE, a CBE and a Knighthood. He made an exception when he was elected to the Royal Academy – 'I oughtn't to have been pleased to get in but I was' he said – though he chose not to attend the annual banquets. None of it was a stand against the establishment. He was just a guarded, solitary man. Those qualities, however, were doubt-less what fired the way he saw the world. His paintings of the smoke-belching towns of his native Lancashire and its people are unmistakable. He was drawn, he said, to their 'poverty and loneliness,' which had a 'private beauty that has haunted me most of my life.' Cotton mills, town squares and street corners feature in the greater part of his pictures, but he also painted coastal scenes, some inspired by childhood holidays, some by trips to Berwick made after he retired from his job as a rent collector. But it's doubtful he so much as stuck his toe in the sea. He is never in or even close to the crowd, when he paints it, merely observing from a distance.

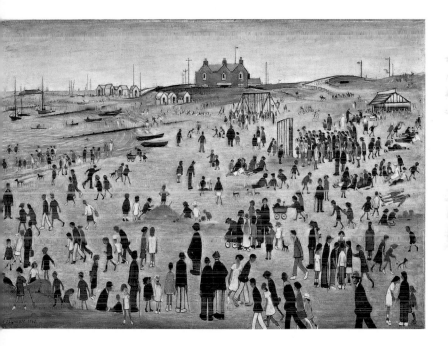

July, the Seaside, 1943, L.S. Lowry, oil on canvas, 667 × 927 mm, Arts Council Collection

1943–45 (St Ives, Cornwall), 1943–5

Knick knacks take the foreground in modern art

It's bewitching to see how Ben Nicholson turned unremarkable objects, like mugs and fishing boats, into fiercely experimental modern art. Look what a world of sensation he creates with those simple ingredients. We can imagine the sound of water slapping the jetty walls, and how the wind whipping the chimney smoke might make the curtains billow into the room. This evocative painting depicts the harbour of St Ives where Nicholson, a key figure of the London avant-garde, moved at the start of the war with his second wife, the sculptor Barbara Hepworth (p.92), and their three children. Pre-war, Nicholson had been making radical white reliefs, but now his dealer wanted British landscapes that could tap into the nation's wartime patriotism. It could have been stultifying, but Nicholson set to it in the only way he could: playing fast and loose with the genre's 'rules'. The painting is also a self-portrait: the artist present in the objects that belong to him on the sill. Nicholson had an incredibly sensitive, even affectionate relationship with his collection of jugs, decanters and mugs. He kept most of them all his life and they populate his paintings like actors in a cycle of plays.

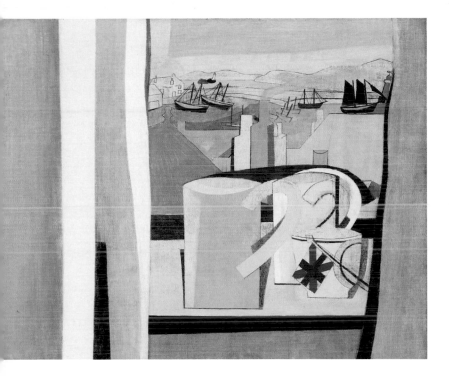

1943–45 (St Ives, Cornwall), 1943–5, Ben Nicholson, oil and graphite on canvas, 406 × 502 mm, Tate

Girl with a Kitten, 1947

A young woman under intense scrutiny

This ferociously descriptive portrait is one of three Freud made in 1947 of his soon-to-be-wife, Kitty Garman, when she was 21. He painted her five times more before they divorced in 1952, yoking her decisively to his artistic development. Pre-Kitty, he worked in pencil, crayon and charcoal – 200 drawings for every painting, he said – and his first paintings of her, like this one, are a continuation of his fastidious early style. But come the 1950s Freud became restless: 'The idea of doing paintings where you're conscious of the drawing and not the paint just irritated me,' he said, and so he stopped. The daughter of sculptor Jacob Epstein, for whom she also posed, Kitty must have been accustomed to scrutiny, though perhaps not at a Freud-level. In search of 'accuracy' and 'focus' he positioned himself a scant foot away. You see it in her sticky eyelashes, in the minute reflection of a window in her eye. Even the static framing her head was fair game, though in all that careful enunciation of detail some vitality is lost. The painting best succeeds as a reincarnation of one of Leonardo da Vinci's most famous portraits, *Lady with an Ermine (c.*1489–91*)*. In glance, in grasp, in how the animal delivers a copy image of its owner, the women mirror each other across the centuries, though the anxiety Kitty radiates is all her own.

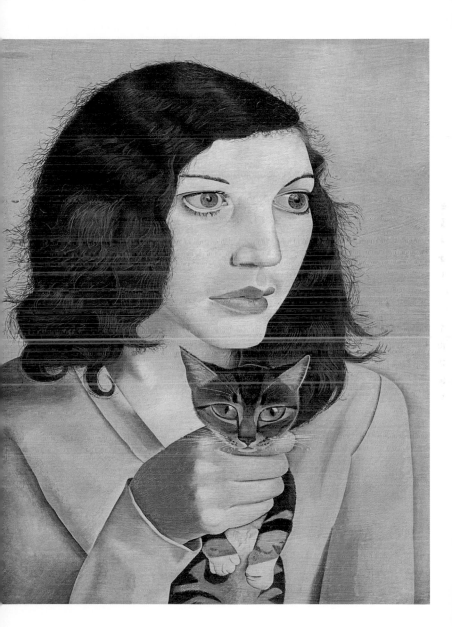

Girl with a Kitten, 1947, Lucien Freud, oil on canvas, 395×295 mm, Tate

Head VI, 1949

The horrified face of post-war angst

Bacon's screaming popes are up there with Paul Cézanne's apples and Andy Warhol's soup tins as some of the best-known images in art. The motif suited perfectly the brittle psyche of post-war Britain and shot Bacon to prominence as our high priest of existential angst. Margaret Thatcher referred to him as 'that man who paints those dreadful pictures.' *Head VI* has its roots in a 1650 portrait of Pope Innocent X by Velázquez. Bacon was 'haunted and obsessed by the image … its perfection,' he said, and found it 'thrilling' to paint from a picture that so excited him. The pope is incarcerated inside a transparent chamber – possibly inspired by nihilist philosopher Friedrich Nietzsche's 'wretched glass capsule of the human individual'. His book, *The Birth of Tragedy* (1872), was one of Bacon's favourites. The deeper you dig into this painting, the more you discover: besides the Velázquez, there are references to medical illustrations, press photographs and even the silent film *Battleship Potemkin* (1925), in which the camera fixes on a screaming wounded woman. The Pope's mouth is the great silent hole in which all the energy of the painting is concentrated. If war-fatigued Britain were in any doubt, *Gott ist tot* – as Nietzsche proclaimed – God is dead.

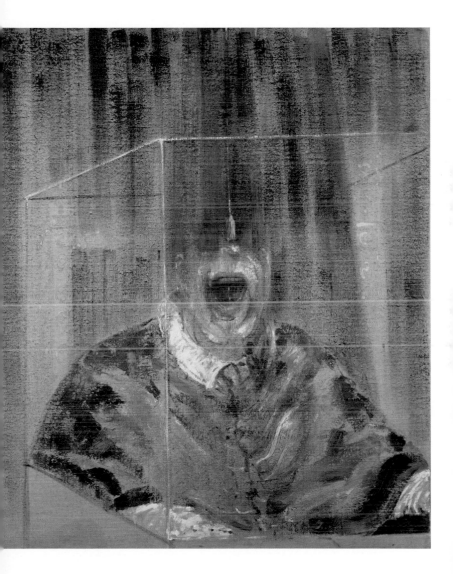

Head VI, 1949, Francis Bacon, oil on canvas, 932 × 765 mm, Arts Council Collection

The Newcastle Bar, 1950s

Realities of mining life by a pitman painter

Cornish was as partial to a pint as he was to paint. 'It must be awful,' his wife would say, when he came home tired after a shift, but he usually managed to find it in himself to head down to the pub so he could get on with his other work. The pitman-turned-artist produced hundreds of paintings describing the collier's lot in County Durham. 'What it felt like to live in my bit of time; my own slice of history,' is how he described it. He was 14 when he started work – his colliery was known as 'The Butcher's Shop' for its accident rate – and 15 when he discovered the local sketching club. Art helped many miners who could not find the words to describe their uncommon and often lonely experience underground, though Cornish is perhaps the most acclaimed. His pictures record a way of life that has all but vanished: weary miners heading to work, pit machinery wheeling over the landscape. His work could have been rancorous, or mawkish, but it isn't. Some pieces are positively affectionate: particularly pitmen in the pubs, as in this painting. Cornish loved the 'wonderful shapes' the men made, standing at the bar. Prime Minister Edward Heath bought his work, as did artist L.S. Lowry, though unfortunately, Cornish said, 'I was not wealthy enough to return the compliment.'

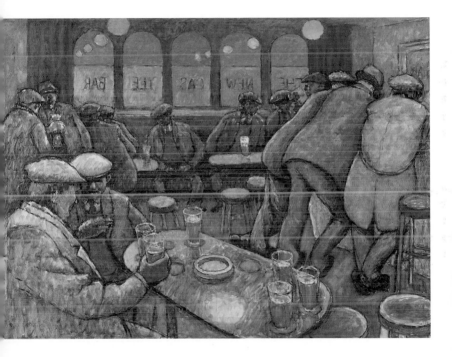

The Newcastle Bar, 1950s, Norman Cornish, oil on board, 895 × 1207 mm, Private collection

Peeled Lemons, 1958

Turning peel into poetry

It's difficult to tally the hand that made this extraordinary, exacting study of bright-skinned lemons with the man who, when filling out registration forms in French hotels, enjoyed listing his profession as '*dompteur*' – lion-tamer. But to Hodgkin, the world was brimming with rowdy plenitude and strange beauty, and he went at it with enthusiasm. His subjects included flint and fungi, flowers, fruit, bones and old boots cast up by the tide, and he painted them with such skill that, as one critic stood in front of a painting of feathers remarked, 'a viewer holds his breath lest he blow them away.' Hodgkin painted in tempera – a fast-drying, onerous medium for which pigment is mixed with egg yolk and various oils – not for its illustrious pedigree (favoured by everyone from ancient Egyptian scribes to the early artists of the Italian Renaissance) but because it was the only medium in which he could express the detail and the character of the objects that fascinated him. 'It combines clarity and definition with a certain feeling of remoteness,' he said, which suited his desire 'to show things exactly as they are, yet with some of their mystery and poetry, and as though seen for the first time.'

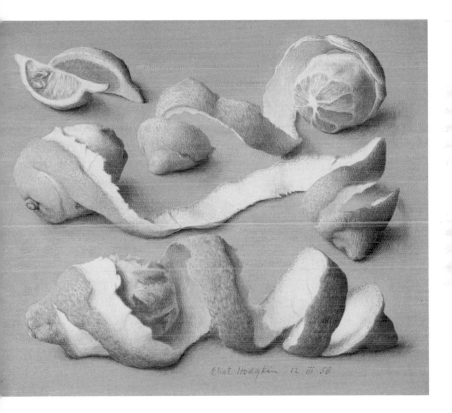

Peeled Lemons, 1958, Eliot Hodgkin, tempera on board, 215×247 mm, Private collection

Self-Portrait with Badges, 1961

A Pop Artist displays his Americana

Peter Blake was at the Royal College of Art when he made this self-portrait. He was a bit of an outlier there, having come up through technical college in Gravesend where he studied graphic design. He also dressed like a Mod when most students were lolloping about the art rooms in corduroys and polo necks. Denim jeans and jackets – essential Mod gear – had only recently become available in Britain, though Blake had been cutting his own from boiler suits for years. That plus the baseball boots, Pepsi badge and his Elvis magazine proclaim Blake's esteem for American pop culture. It seems so bold and bright compared to the suburban setting, even if this balding, mournful artist is less Rebel Without a Cause, than shy with multiple causes. The pose – and the air of melancholy – echo grand portraits of the past, particularly Gainsborough's *Blue Boy* (1770). Subconscious, Blake says, but those historical antecedents enrich the painting. The portrait won him a prize, and soon after, a drawing commission from the *Sunday Times* in California. It was his first trip to the hallowed lands, and he did it in style – in a gold Corvette Stingray.

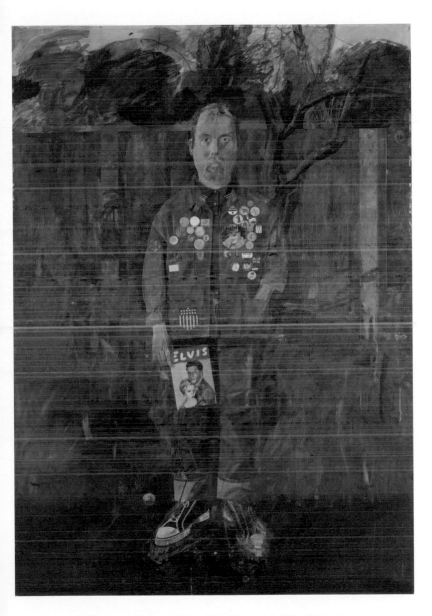

Self-Portrait with Badges, 1961, Peter Blake, oil on board, 1743 × 1219 mm, Tate

JANN HAWORTH

Cowboy, 1964

The sculpture that carved a new niche

Haworth was a pioneer of the Soft Sculpture movement – one of a handful of artists drawn to making sculptures with materials including cloth, canvas and foam in the early 1960s. For Haworth, experimenting with the 'stuff' of sculpture was a calculated move: at the Slade, a male tutor told Haworth that women were only admitted to the school to keep the boys happy. She took up sewn cloth, she said, because it seemed to her a secret language 'that my male colleagues had no inkling of ... very much female and something I had the edge on.' *Cowboy* is stuffed calico, his squishy yet comely life-size form radiating personality. Stand in front of him, and you half expect him to tip his hat or offer you a smoke. Haworth grew up on film sets – her father was a Hollywood production designer – where props and surreal realities soaked into her way of seeing. She made soft sculptures of other tokens of Americana, including doughnuts and comics. *Cowboy* can be glimpsed in some early out-takes on the set of The Beatles' *Sgt. Pepper's Lonely Hearts Club Band* album cover, which she co-created with her then-husband Peter Blake, and for which she has only recently been credited – but regrettably the sculpture didn't make the cut.

Cowboy, 1964, Jann Haworth, kapok and unbleached calico, 1803 mm, Pallant House Gallery

Atom Piece, 1964–5

A work straddling hope and catastrophe

At 3:36pm on 2 December 1942, in a secret lab beneath a football field at the University of Chicago, the physicist Enrico Fermi performed the first controlled nuclear reaction, splitting an atom without a deadly explosion. In 1963, the University commissioned Henry Moore to make an outdoor sculpture commemorating Fermi's momentous discovery. *Atom Piece* – a seemingly celebratory metallic dome that morphs quickly into the shape of a skull – was Moore's working model for the final sculpture, and no less potent. What you see depends on your feelings about atomic power. Hope, terror, devastation, beauty – the dome's warm gold brilliance was deliberate – the sculpture twitches with these clashing perspectives and emotions. Three years earlier, Moore had added his signature to a letter denouncing atomic weapons. He said that he had to remind himself as he worked, that 'nuclear power is both for good and bad, it is not all destructive.' But *Atom Piece*'s combination of skull and cloud may have been informed by H.K. Henrion's poster for the Campaign for Nuclear Disarmament – Moore was one of the organisation's founding sponsors. He made seven casts of *Atom Piece*, one of which was acquired by Hiroshima, the Japanese city destroyed by a nuclear bomb in 1945.

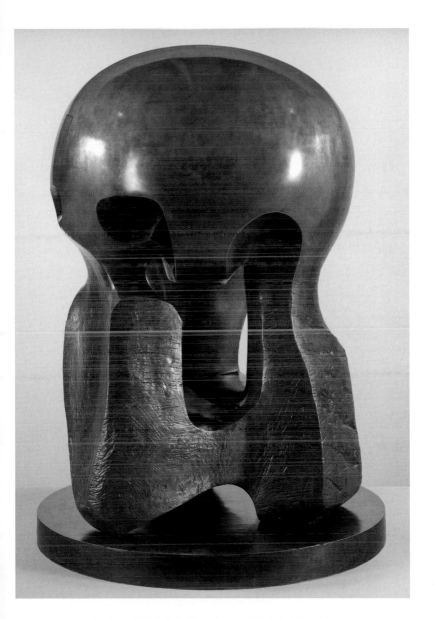

Atom Piece, 1964–5, Henry Moore, bronze, 1270 × 920 × 920 mm, Tate

Mr and Mrs Clark and Percy, 1970–71

20th-century marital tensions

It seems so supremely 1970s, this double portrait of the artist's friends, Ossie Clark and Celia Birtwell. Plastic phone, long-pile rug, bare feet, Chelsea collar and kaftan – it couldn't be more Age of Aquarius if it tried. But Hockney is nothing if not agile, and the painting's outwardly straightforward surface is stiffened by smart, piquant little flashes of pictorial tradition. Ossie's shoulder-length waves and fine, forceful chin have wheeled through time from 1400s Florence. Its set up resuscitates the 'conversation piece' – faux-informal group portraits in domestic settings that were all the rage in the 1700s. It's particularly like Gainsborough's *Mr and Mrs Andrews* (p.38), only Hockney has reversed his Mrs and Mr. He made a cluster of double portraits, all of them almost life-size, at the end of 1960s. All of them set in a never-ending triangle: one subject looks at the other, who looks out at Hockney, or, as here, both look out at him. *Mr and Mrs Clark* was actually a wedding present, though the Clarks' relationship was already in tatters. Did Hockney weave his inside knowledge into the painting? Many have noted a tension in the couple's stance. But then, hindsight is a wonderful thing.

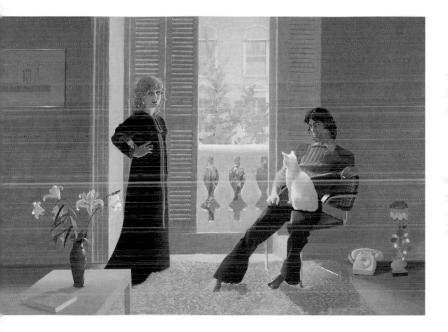

Mr and Mrs Clark and Percy, 1970–71, David Hockney, acrylic on canvas, 2134×3048 mm, Tate

Tony's Anvil, 1975

Abstract cascade of incandescent colour

As a young man, Frank Bowling was fascinated by the abstract artist Piet Mondrian's palette of pure colours. You see it here: red, yellow, blue, black. But *Tony's Anvil* (named for Bowling's friend, the sculptor Anthony Caro) burrows much further into colour than that. It's one of a series of paintings he made in 1960s New York where, buoyed up by the feeling of 'freedom to do whatever one wanted' he found there, he constructed a tilting platform for the canvas so he could control (to a certain extent) the onward slosh and run of the paint he dribbled onto it. Pouring paint wasn't new (Jackson Pollock had been making drip paintings since 1947 and Helen Frankenthaler her soak stains since 1952), but in Bowling's hands it became philosophical. In making the painting's creation process its subject, Bowling was responding to Clement Greenberg – America's most influential critic – who believed that painting had to analyse itself to discover its true nature. Greenberg encouraged Bowling's experiments, and the two became 'lifelong friends'. Looking to be surprised by colour freed Bowling to play with it endlessly; having smeared it, spattered it, layered it, cut into it and even embedded objects in it, he is still going. As he says, 'the possibilities of paint are never-ending.'

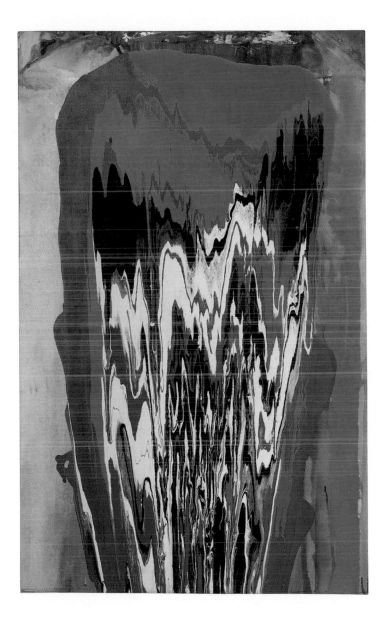

Tony's Anvil, 1975, Frank Bowling, acrylic on canvas, 1727 × 1067 mm, Private collection

In the Kitchen
(Washing Machine), 1977

Performance piece satirising the domestic goddess

One of the most original artists in 1970s Britain, Helen Chadwick queried female identity and gender roles in an emphatic and bitingly funny fashion. Her influence on the YBA generation was profound – a great number of whom were her pupils. Chadwick frequently involved her own body in her work: in bronze castings of urine-melted snow, for instance, and photographs of the Pembrokeshire coast that she coated with cellular tissue from her mouth, ear, cervix and kidney. *In the Kitchen* was a performance, staged for her MA at Chelsea. It exists today as a set of photographs and satirises the domestic goddess – the idea that women are naturally suited to certain roles. For the performance, Chadwick and three other women wore sculptures made from metal frames with PVC skins. Each represented a kitchen appliance: *Washing Machine*, *Oven*, *Fridge* and *Sink*. The women's bodies are encased inside and blend with the machines, which take on human characteristics in turn – the washer-dryer here reminiscent of old anatomical models in which viscera or wombs are happily on display. The series upset some feminists, who argued Chadwick's use of nude bodies replicated sexist stereotypes, though she argued back: she and the other women were subjects, not objects of desire.

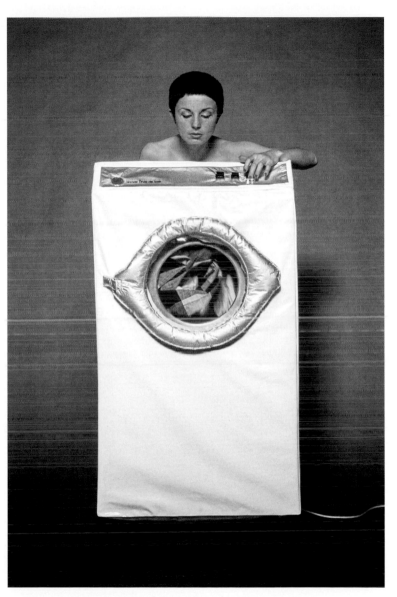

In the Kitchen (Washing Machine), 1977, Helen Chadwick,
colour archival pigment print, 419 × 277 mm, Richard Saltoun Gallery

Missionary Position II, 1985

Double self-portrait about miscommunication and frustration

At 25, Sonia Boyce became the first Black woman to have her work enter the Tate collection. It was this pastel drawing, purchased in 1987. Boyce took up pastel after learning how the medium had historically been a form of resistance among female artists, who, because they were excluded from the academies, had little opportunity to learn the knack of painting in oils. An exhibition of Frida Kahlo paintings, meanwhile, had encouraged Boyce to feature her own life in her work. *Missionary Position II* mirrors Kahlo's *The Two Fridas* (1939): both paintings are double self-portraits and explore contesting identities. At the time, self-portraits were important to Boyce. At art school she felt that, 'the tutors were dismissive. I was Black, therefore I wasn't there. I needed to see myself'. This painting is less about her appearance, though, than a vehicle for her concerns about relationships in which there is an imbalance of power. The title has multiple connotations: Britain's 'mission' of empire-building; the strict sexual propriety advocated by missionaries in Africa; the submission of Black society to white. In Kahlo's painting the two figures clasp hands, but here, that instance of connection is broken. Closed eyes, that unmet outstretched arm. It's all about miscommunication, and frustration.

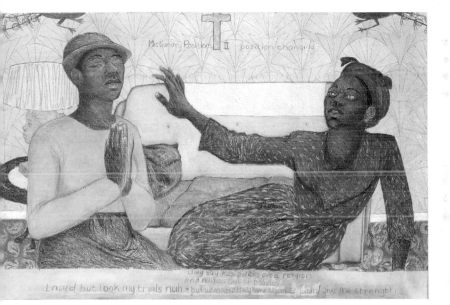

Missionary Position II, 1985, Sonia Boyce, watercolour, pastel and crayon on paper, 1238 × 1830 mm, Tate

The Physical Impossibility of Death in the Mind of Someone Living, 1991

An uncanny memento mori

Damien Hirst's formaldehyde-pickled shark floored every person who saw it when it was first shown at the 'Young British Artists I' exhibition, in 1992. Hirst wanted to convey 'power and menace', and he did. It was Jaws and every nightmare we ever had about him, but with a hefty dose of metaphysical angst that trailed right after you out of the gallery. As Spielberg's Quint says: 'This shark, swallow you whole'. *The Impossibility of Death in the Mind of Someone Living* was a marvel – infernally clever, nuanced, a shot of adrenaline to contemporary conceptual art. For a few years at least, British artists were the most famous on earth and Hirst was their rowdy frontman. People tend to love him or hate him – and some people really do hate him – but he remains one of the most talked about artists of our age. If time has not been kind to Hirst's reputation, it has been worse to the shark. Rumours that it was rotting began in the late 1990s. In 2000, it was rejected by a museum in Paris. When, four years later, it was sold to a private collector, Hirst replaced the shark and upped the formaldehyde. The new model has a 200-year guarantee.

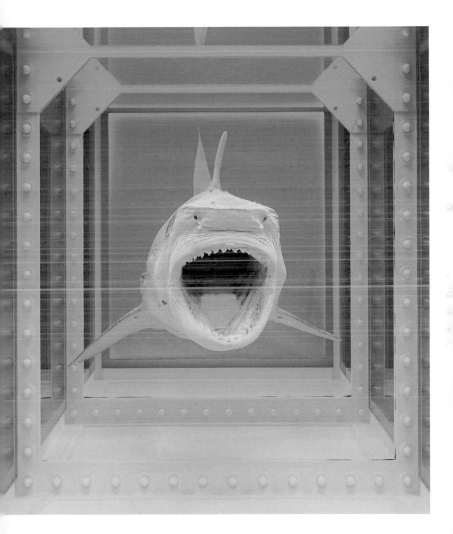

The Physical Impossibility of Death in the Mind of Someone Living, 1991,
Damien Hirst, tiger shark in formaldehyde, 2180 × 5420 × 1800 mm, Private collection

House, 1993

Cast of a ghost house that sparked public debate

Demolished after only 80 days, this concrete cast of a condemned terraced house in London's East End sparked a row that fed off local tensions fuelled by gentrification. Whiteread had cast a room before, but *House* required some serious engineering: an internal metal skeleton was built onto which concrete could be sprayed from the inside at high velocity. Seventy miles away, the same technique was being used for the Channel Tunnel. Once its original brick exterior was removed, *House* revealed its insides to London. Imprinted in its sides were the ghosts of windows, electrical cables, fireplaces and even streaks of paint. What Whiteread had called into being was a charged space that was soaked with the lives of the people who had slept and laughed and doubtless wept there, and as much a part of the house's fabric as the intervals are between notes in a piece of music. Everyone had an opinion. Masterpiece. Eyesore. Keep it, demolish it – the argument went as far as Parliament. Whiteread was anti-permanence. Much more interesting, she said, if a project engaging with the idea of memory becomes a memory itself.

Rachel Whiteread's House, 1993, reinforced concrete, photograph by Richard Baker

Object for the television, 1994

Surreal sculpture that defies monumentalism

Phyllida Barlow's sculptures have a grimy lawlessness about them. Rather than bronze or stone, Barlow used reclaimed timber, papier-mâché, tar, scrim, cement and black bin bags, often in the same work. It all comes together in dramatic installations that defy and spoof the monumentalism and immaculate finish of her predecessors. Having to duck under or squeeze around it is often part of the piece. She once described her art as 'an adventure of objects', which is about right. Barlow was in her mid-sixties when she gained international recognition. The work shown here is from long before that – a time she categorised as 'a lot of teaching and a lot of parenting'. She had to duck under and squeeze around those restrictions, too, working in short bursts and with whatever she had to hand, which is how her 'Objects for ...' series came about. Juxtaposing familiar household items with abstract sculptural forms, it included an envelope for a piano, a larva-like creature on an ironing board and this bunny-eared beret for a television. It's funny, vital and disconcertingly suburban, but it also foreshadows the way Barlow's mature work short circuits our constant wish for things to make sense.

Object for the television, 1994, Phyllida Barlow, plaster,
television and television stand, 1508 × 1035 × 515 mm, Tate

The Blue Fairy Whispers to Pinocchio, 1996

A dream-like scene wavering between tenderness and malice

Faced with saving one Paula Rego picture from a burning building, it would be this one. It's a sublime, unspeakably haunting reimagining of the wooden puppet and his guiding spirit, in which a naked child – we see his inert figure only from the back – is wreathed by a sinewy, large-limbed woman. Is she admonishing or comforting him? Is he afraid or reassured? Sketches for the work show that Rego experimented with both slants, but in the finished piece we can't quite tell, and that's part of its spell. Fables, folktales and classic literature reoccur in a lot of Rego's work, but usually bruised or undermined in some mischievous or lacerating way. Once seen, they change your view of the original utterly, though that seems to be her aim: 'I always want to turn things on their heads,' she said, 'to upset the established order.'

The Blue Fairy Whispers to Pinocchio, 1996, Paula Rego,
pastel on paper on aluminium, 1700 × 1500 mm, Victoria Miro

My Bed, 1998

The bed Emin spent four self-destructive days in

My Bed incited civil and critical uproar when it was first shown at the Tate in 1999 having been nominated for the Turner Prize, and it didn't even win. Or did it? The bed's shock value might have dissipated, but its status is still controversial: for every person who insists it's a landmark of contemporary British art, there is another who sees only a jumble of emperor's new clothes. Push the is it/isn't it question aside though, and *My Bed*, which consecrates the bed Emin spent four self-destructive days in, nursing her grief over the end of a relationship, is deftly – even beautifully – nuanced. Like all good art, it tells a story – here a kitchen-sink drama about Emin's tumultuous emotional life. It's also a portrait of melancholy, in the vein of Dürer, Artemisia Gentileschi and Edvard Munch. And it takes Duchamp's impersonal 'readymade' and infuses it with a fierce emotional heat. Whichever of these traditions you choose, Emin has engaged with it in the most provocative way possible.

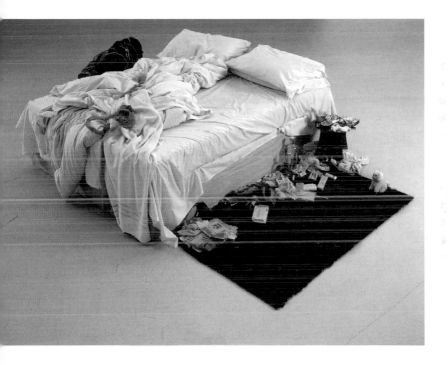

My Bed, 1998, Tracey Emin, box frame, mattress, linens,
pillows and various objects, overall display dimensions variable, Tate

Mono Amarillo, 1999–2002

Radiant installation that enchants the viewer

The Upper Room is an installation of 13 colour-themed paintings – including the yellow work shown here – in a walnut-veneered, nave-like chamber. The room is dark, the paintings spot lit, throwing puddles of faintly patterned and coloured light onto the floor. You reach it via a Stygian corridor, whose length was precisely calculated by Ofili's collaborator, the architect David Adjaye, to ensure that when you reach the paintings, their crackling radiance is all the more exhilarating. It's designed to create 'a total experience of looking … and revelling in that feeling,' Ofili has explained. The careful arrangement of 12 canvases flanking a larger thirteenth suggests Christ and his Apostles (in the *New Testament*, the Last Supper took place in 'a large upper room'). Instead of men, though, we have goblet-holding, hat and waistcoat-wearing rhesus macaque monkeys – the children of a 1957 collage by Andy Warhol. Dusted in glitter, they shimmer and fizz as though emitting light, hovering nanometres above their foliage and flower backgrounds. Ofili's near limitless imagination detonates endlessly, in spiralling patterns, in filo-like layers of resin and gold leaf, and not least in the elephant dung that supports and dots each canvas. Mind bombs every one, and an unqualified delight.

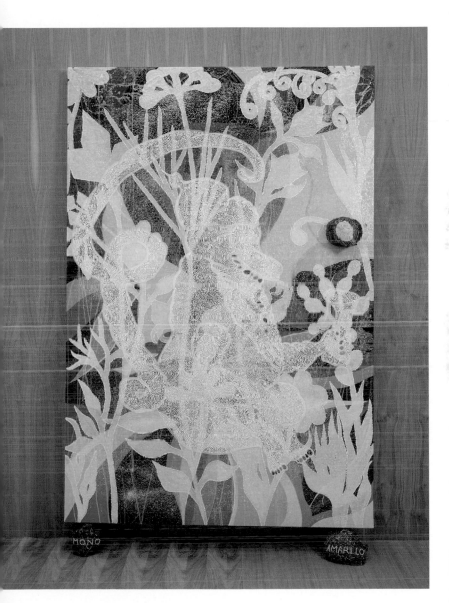

Mono Amarillo, 1999–2002, Chris Ofili, oil paint, ink, polyester resin, glitter,
map pins and elephant dung on linen with two elephant dung supports, 1832 × 1228 mm, Tate

Mornington Crescent, Summer Morning II, 2004

Sensational study of north London

This gleaming, liquid painting – all bilious lines and zigzags – describes a hot summer's morning in London. It's a particular atmosphere and a particular time of day but informed by a lifetime of looking. Auerbach has been painting this little corner of north London for 70 years, and it hasn't yet stopped repaying his attention. He began painting the capital as an art student post war, when it was wracked and fire-blackened. 'I had been through the war, we'd all survived,' he explained, 'it seemed to be rather urgent that I try and pin this down.' As the city recovered, Auerbach continued to document it. Initially he roamed all over the place, but since moving to his studio in Camden Town in 1964, he has focused on nearby streets, like this one. He begins with in situ drawings, but it's what happens afterwards that gives his paintings their sensation-rich intensity, since he paints, scrapes off, repaints, re-scrapes, paints again – hundreds of times. By his own calculation, 95 per cent ends up in the bin. 'I rehearse all the other ways until I surprise myself,' he has said. 'It is never just recording the landscape. It always has to do with some sort of feeling about my life.'

Mornington Crescent, Summer Morning II, 2004, Frank Auerbach,
oil on board, 510×510 mm, Ben Uri Gallery and Museum

Blonde Girl Sitting on a Picnic Table, 2007

Portrait of an emotional crossroads

What does it feel like to be a teenager? Many would prefer not to remember, but Chantal Joffe is fascinated by life's brinks. Motherhood, separation, bereavement, old age, anger – her paintings tremble with them. Here it's the long crossing into adulthood, the girl marooned, watchful and a little defiant. Though Joffe sometimes paints from life – in 2018 she made a self-portrait nearly every day of the year – mostly she works with 'found' images from magazines and photographs, including those of her own family. It's her style that's captivating. She paints in a free and fluid way that slips between figuration and abstraction. Her brushwork is elastic, the detail spare, the colour muted – but all of it combines to create such a feeling of realness, such emotional heft. Perhaps those emotions are Joffe's own: she has said that her paintings 'are a mash-up of everything that is preoccupying me at that time' and that, 'the heavier the emotion the more abstract way I use the paint. It's almost like it's too much, they need to be simplified.'

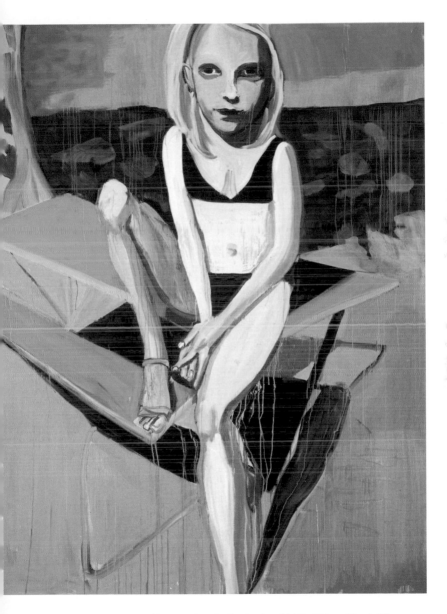

Blonde Girl Sitting on a Picnic Table, 2007, Chantal Joffe, oil on board, 2430 × 1820 mm, Victoria Miro

GRAYSON PERRY

The Adoration of the Cage Fighters, 2012

A very British epic of class and taste

Class and taste. Few issues are as prickly, as riddled with emotion – which is precisely what signalled to Grayson Perry that the subject was worth investigating. His series of tapestries, *The Vanity of Small Differences*, surveys it all – the intricacies of social climbing, middle class angst and 'old money' snobbery – and it is as witty as it is perceptive. To make it, Perry undertook field research in Sunderland, Tunbridge Wells and the Cotswolds, inviting cameras along with him for a genial yet revelatory TV series. The work reanimates Hogarth's *A Rake's Progress*, charting Tim Rakewell's ascent from his working-class roots to 'the sunlit uplands of the upper-middle classes' – Perry's words – to his ignominious end. But if the style is Hogarthian, flushed by early Renaissance religious painting, Perry creates his own rich, strange world, one in which PC World, William Morris wallpaper, fake tan and Old Masters mingle happily. That such things have been considered worthy of tapestry – historically an elite medium confined to depicting classical myths and famous battles – is Perry's masterstroke. They are huge too: designed to linger over and strewn with visual sweetmeats. Each of the six tapestries features a small pug, for instance – presumably a nod to Hogart's cherished pet Trump. Did Britain ever see itself so utterly, so beautifully, summed up?

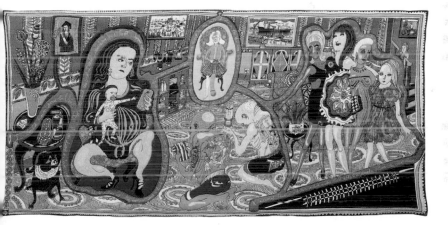

The Adoration of the Cage Fighters, 2012, Grayson Perry, wool, cotton, acrylic, polyester and silk tapestry, 2000 × 4000 mm, Arts Council Collection

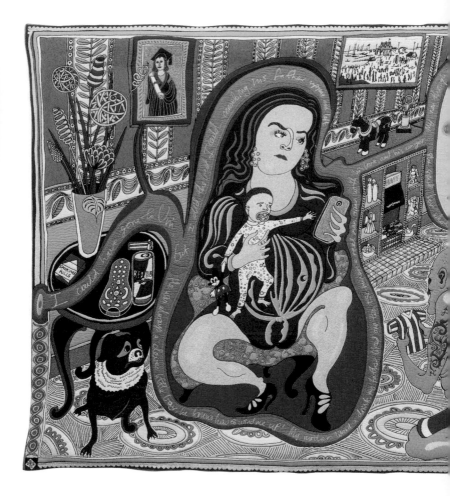

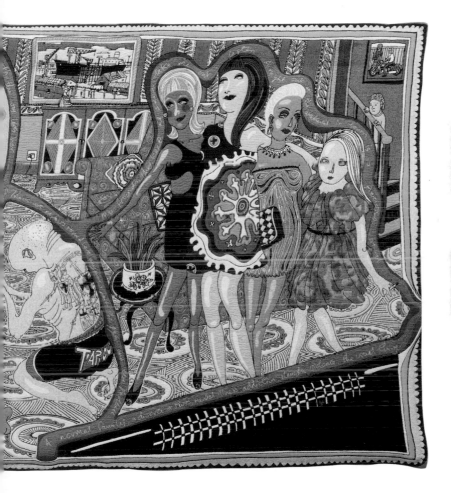

A Passion Like No Other, 2012

Elusive study of an imaginary character

It would be hard to imagine a more dream-like painting than this – the figure glimmering, half dissolved in shadow. It's less a portrait than an opening onto a mirror-world in whose corridors the boy wanders. That hypnotic quality is typical for Lynette Yiadom-Boakye, whose paintings deal in fictions. She paints not from life but by drawing imaginatively on an archive of working images: photos of friends, memories, observations and 'found' images including postcards and scraps of magazines. The reality she conjures is not in the world, but a world unto itself. It's life filtered through memory: dangerous-seeming and exuberant all at the same time. Details like the boy's collar here feel like riddles to be unravelled. Careful though, because even as Yiadom-Boakye invites us to join in – like that game in which one person suggests the first sentence of a story, another person the next, and so on – she also gently rebukes our misguided efforts to extract meaning. Once you accept that the painting will forever be just out of reach, its colour and pattern and brushwork offer something much more special: a chance to lose yourself so utterly that when you turn away you're disappointed by what is real.

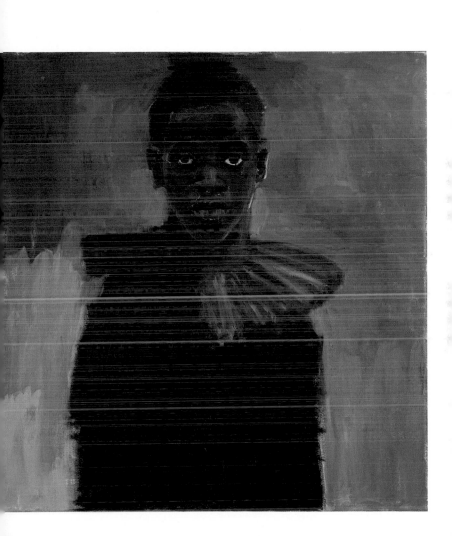

A Passion Like No Other, 2012, Lynette Yiadom-Boakye, oil on canvas, 800 x 752 mm, Private collection

War Room, 2015

Spectacular yet intimate memorial

It's hard not to think of blood or internal organs when you're inside *War Room*, but that's the point. The work is an installation; a room draped with red waste sheets from the factories that make our Remembrance poppies – 45 million each autumn. The paper is suspended, hung like a canopy. It's meant to echo the vast, pavilion-like tent that Henry VIII had constructed for the *Field of the Cloth of Gold* (p.24) in 1520 – the drawings for which are in the British Library collection. The pattern on the paper comes from thousands of perforations: punched-out absent poppies that summon lives lost, the soldiers who never came home, the hole a death leaves in a family's heart. There are two layers of paper and, because the perforations don't exactly overlap, what you get is a mesh that looks like camouflage netting. These layers and their shadows combine to create a hallucinatory ripple effect, compounded by the work's low-watt hanging bulbs. Desolate, stifling, intimate, mystical. You make the space what you will. When it was displayed at the Whitworth in 2015, army veteran choirs turned up to sing inside it – a guerilla act that delighted Parker.

War Room, 2015, Cornelia Parker, paper installation, The Whitworth

Love is in the Bin, 2018

Shredded canvas that made auction history

Many, many artists find the commercial art world insufferable, but few of them would dare to rebuke it in public. But that's exactly what Banksy did when he obliterated a framed version of his 2002 graffiti *Girl With a Balloon* in full view of those assembled for its auction, seconds after the gavel fell. The final lot of the sale, the piece lowered itself through a shredder built into the frame, cutting the lower part of the painting into tiny strips. From an artist who likes to be referred to as a 'quality vandal', the stunt was a scathing satire, excoriating the spectacle and excess of contemporary art. You have to admire his chutzpah for the frontal nature of his guerilla attack – even if the gesture itself isn't new. In 1960, for instance, the Swiss sculptor Jean Tinguely set fire to one of his artworks in front of a couple of hundred people at the Museum of Modern Art in New York. In the case of Banksy, the art market fought back: when the partly-shredded painting was resold in 2018 – by now renamed *Love is in the Bin* – it smashed every expectation selling for £18,582,000.

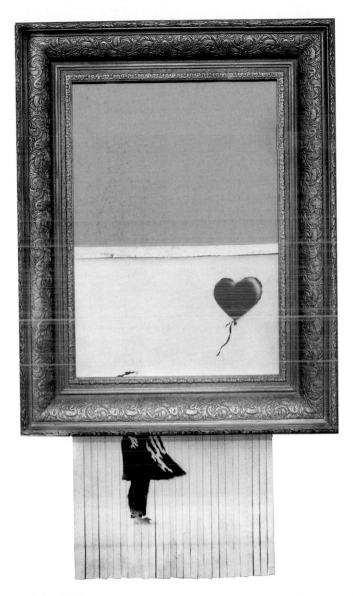

Love is in the Bin, 2018, Banksy, spray paint and acrylic on canvas mounted on board; decommissioned, remote controlled shredding mechanism remains in the frame, 1420 × 780 × 180 mm, Private collection

DAVID SHRIGLEY

Untitled (I Remain Unsold), 2020

Chaotic insights from our preeminent satirist

David Shrigley is our great satirist: part world-weary cynic, part savant. Like his Dada heroes – 'Francis Picabia, Marcel Duchamp: they were the artists I wanted to be' – he dispels distress and dread with a snippety humour. Though Shrigley has a 'no redrawing' rule and discards three quarters of the work he makes in a day, spelling mistakes and crossings-out are fair game. In art world terms, Shrigley is a rare bird. Accepted by the inner sanctum, who nominated him for the Turner in 2013, he happily communes with those beyond it. And he isn't, as this piece shows, afraid of showing and lampooning the canny commercial side of the art scene either. Since he catapulted to fame in the mid-1990s he has stood firmly behind the credo 'Art is for everyone'. His Shrig Shop in Copenhagen, is 'an alternative to the gallery space', in which his work is sold as tattoos, pool inflatables and postcards, as well as the more traditional limited edition prints. Shrigley's 'to hell with everything' outlook is both the inevitable outcome and the perfect partner to our chaotic times. It's also very funny and might just prevent us going mad at the injustice of it all.

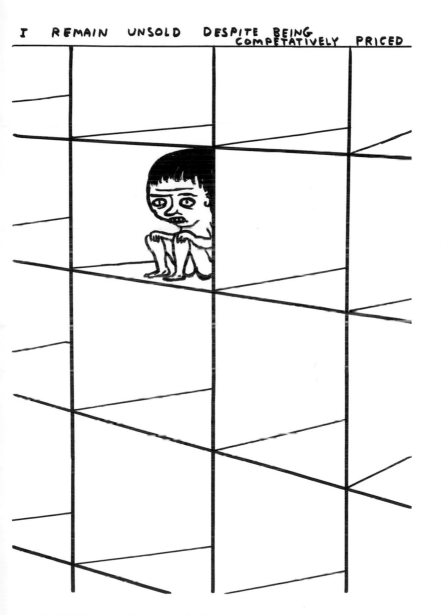

Untitled (I Remain Unsold), 2020, David Shrigley, ink on paper, 420 × 297 mm, Anton Kern Gallery

All In, 2021

Art that can reimagine representation

Statues and race make for a heavily politicised context at the moment, but in Thomas J Price's hands, the outcome is sublime. The figurative nature of his sculptures is tantalising bait – a means of reeling the viewer in for what he describes as a 'nonverbal discussion'. Rather than immortalising individuals, each piece is a rich amalgam, blending the features, clothing and stances of people Price has seen on the street with ancient Greek and Roman sculptures and media stereotypes. In representing contemporary people of African descent, old ideals concerning who art celebrates and how are skewered. Particularly public monuments, which have focused on dead white European males. 'I want people to recognise themselves and feel valued,' Price says. In size (most of his public sculptures are at least 9ft tall; *All In* a colossus-like 12ft) and in material (here bronze) Price engages with notions of status and authority. But if this figure towers over their space, the honesty of their depiction, their rumpled clothing and faraway look, makes them oddly vulnerable. It is Price's grasp of flickering, seductive possibilities – the idea that a sculpture might be radically unresolved, inquisitive, and we 'engaged participants' rather than audience members – that opens up something truly new for the future of British art.

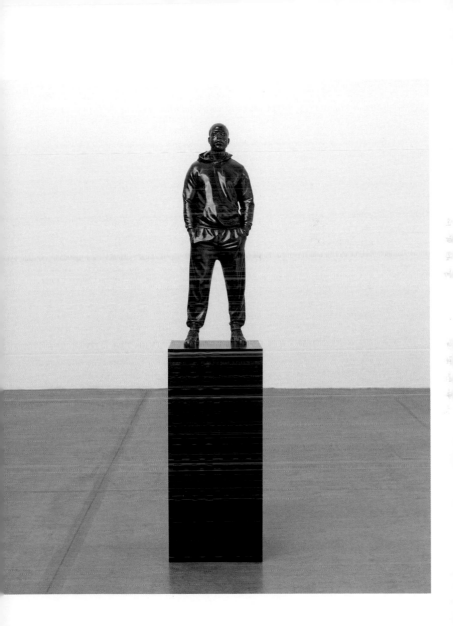

All In, 2021, Thomas J Price, bronze, 3690 × 1280 × 850 mm, Hauser & Wirth

Artist Directory

Harry Epworth Allen
b.1894, Sheffield
d.1958, Sheffield
A clerk in the local steel works, Allen attended the city's Technical School of Art in his spare time. From 1931, he painted full-time and joined the Yorkshire Group of Artists, exhibiting at the RA and eventually in America.

Frank Auerbach
b.1931, Berlin
He was sent to Britain in 1939 on Kindertransport. One of the post-war figurative painters in the group known as the School of London, he found commercial success in middle age and is now considered as significant as his friends Francis Bacon and Lucian Freud. Famously, he worked from the same small Camden studio for almost 50 years.

Francis Bacon
b.1909, Dublin
d.1992, Madrid
Son of a steel heiress and a racehorse trainer, Bacon was severely asthmatic, tutored at home and banished at 16 for his sexuality. He drifted about Paris and Berlin before settling in London. He worked briefly as a designer of rugs and chairs, but then took up painting – without any formal training – for which he earned instant notoriety.

Banksy
?
This anonymous artist started out freehand, but changed to stencils after spotting one on the underside of a bin lorry while hiding from the police. Variously 'outed' as Robin Gunningham, Robert Del Naja of Massive Attack and even a collective of artists. Then again, perhaps all of the above were red herrings …

Phyllida Barlow
b.1944, Newcastle
d.2023, London
The great-great-granddaughter of Charles Darwin, Barlow attended Chelsea School of Art and the Slade. She taught sculpture for 40 years, influencing artists including Tacita Dean and Rachel Whiteread. She found fame at 73 when she represented Britain at the Venice Biennale.

Vanessa Bell
b.1879, London
d.1961, Charleston
Co-founder of the Omega Workshops Ltd, an artists' co-operative for decorative arts, Bell was a central figure of the Bloomsbury Group. She studied under John Singer Sargent at the RA and exhibited in the landmark 'Second Post-Impressionist Exhibition'. Married to art critic Clive Bell, she was a muse to fellow painters Roger Fry and Duncan Grant, her romantic partner.

Peter Blake
b.1932, Kent
He initially studied at Gravesend Technical College, where he began to collect popular art and ephemera. Afterwards he attended the RCA where, along with fellow students David Hockney and R.B. Kitaj, he played a crucial role in the emergence of Pop Art. He designed the album cover for The Beatles' Sgt. Pepper's Lonely Hearts Club Band with his first wife Jann Haworth. Elected as a Royal Academician in 1981, he was knighted in 2002.

William Blake
b.1757, London
d.1827, London
His father was a Soho shopkeeper. He attended drawing school at 10 and was a poet by 12. He made his living as an engraver, a craft he studied at the RA. He invented a method of making his own prints so that he could combine illustrations and text on the same page, giving him unusual independence of expression.

Frank Bowling
b.1934, Bartica
Bowling moved to London in 1953 when he was 19. An early passion for poetry and two years in the RAF gave way to studies at the RCA. Visiting New York at the peak of Abstract Expressionism convinced him to abandon the human figure in favour of abstraction. He was elected as a Royal Academician in 2011, and he was knighted in 2020.

Sonia Boyce
b.1962, London
She studied at Stourbridge College before emerging in the 1980s as a key figure in the Black British Arts Movement. Her early pastel drawings and photographic collages have evolved into installations incorporating collages, films and sound. She was awarded

an OBE 2019 and won the Golden Lion at the Venice Biennale in 2022.

Helen Chadwick
b.1953, London
d.1996, London
Widely exhibited in her lifetime, following her unexpected death from a virus at 42 her work has not had the attention it deserves. She taught at art schools across London, where she influenced many of the YBAs. Her installations addressing power and gender relations achieved notoriety and she was nominated for the Turner Prize in 1987.

John Constable
b.1776, Suffolk
d.1837, London
He learned painting from a local plumber and glazier who was also an amateur artist. Constable then entered the RA Schools in 1799. He exhibited there almost every year until his death. His paintings were acclaimed by French artists and awarded a gold medal at the Paris Salon in 1824.

Norman Cornish
b.1919, Spennymoor
d.2014, Spennymoor
He began work as a coal miner at 14 and it wasn't until 1966, after 33 years in the coalfields, that he risked making his living by painting. He became one of the most sought-after contemporary artists in the country and the most famous of the 'pit painters'. He was awarded an honorary MA by Newcastle University in 1974.

Evelyn Dunbar
b.1906, Reading
d.1960, Wye
She enjoyed early success illustrating children's books. She studied at the RCA, and wrote and illustrated the book *Gardeners' Choice* with her mural tutor Charles Mahoney. She taught at Ruskin School of Art but sank into obscurity until a centenary exhibition in 2006 and the discovery of hundreds of lost paintings restored her reputation.

Eadfrith of Lindisfarne
d.721, Northumbria
A monk at Lindisfarne who became bishop in c.698 and remained incumbent until his death. Buried on the island, when the Vikings raided his remains were dug up and hidden by the monks. Today his remains are buried in Durham Cathedral.

Tracey Emin
b.1963, London
Raised in Margate, she studied fashion and printing before attending the RCA. Friendly with some YBAs, she did not join ranks artistically until the early 1990s. Emin and Sarah Lucas opened 'The Shop' in Bethnal Green in 1993, the same year as her first solo exhibition at the White Cube. Nominated for the Turner Prize in 1998, she was awarded a CBE in 2013.

Jacob Epstein
b.1880, New York
d.1959, London
He first began sculpting at night school while working at a foundry in New York, before attending the École des Beaux-Arts and the Académie Julian in Paris. He then settled in London and became a British citizen in 1907. A founding member of The London Group in 1913 (which exhibited avant-garde art), he was knighted in 1954.

Lucian Freud
b.1992, Berlin
d.2011, London
The grandson of Sigmund Freud, his family fled to England in 1933. He studied at Central Saint Martins and Goldsmiths then the East Anglian School of Painting and Drawing, and represented Britain at the Venice Biennale in 1954. Almost as famous for his voluminous love life as his portraits.

Thomas Gainsborough
b.1727, Suffolk
d.1788, London
Pupil of the French illustrator and draughtsman Hubert François Gravelot, he was hugely influenced by rococo art. He moved to the fashionable spa town of Bath, where he achieved instantaneous success. A founding member of the RA, he quarrelled with them about the hanging of his pictures.

James Gillray
b.1756, London
d.1815, London
Apprenticed to an engraver and enrolled at the RA, he abandoned his studies to draw satires instead. The first serious artist to become a caricaturist, he was sought after and feared. After producing nearly 1,000 prints in 30 years, his failing eyesight led to depression and, allegedly, auto-defenestration.

Jann Haworth
b.1942, California
Haworth came to England in 1961 to attend the Courtauld then the Slade, where she met and soon married Pop Art artist Peter Blake. Co-founder of The Brotherhood of Ruralists, which rejected abstractionism and showed at the RA in 1976, she was a pioneer of soft sculpture and an advocate for women's representation in the art world.

Barbara Hepworth
b.1903, Wakefield
d.1975, St Ives
She had a scholarship to Leeds School of Art and afterwards attended the RCA. Hepworth learned from a master-carver in Rome, and eventually became part of a circle including Henry Moore and Ben Nicholson, her second husband. She moved to St Ives in 1939 and was prolific in her later years.

Nicholas Hilliard
b.1547, Exeter
d.1619, London
The son of a goldsmith, he was the first notable English artist of miniature painting. It's not known how he learnt the art, but by 1572 he was appointed the official 'limner', or miniature painter, of Eliza beth I, a title he kept when James I acceded to the throne.

Damien Hirst
b.1965, Bristol
He grew up in Leeds where as a 16-year-old he made regular visits to the anatomy department of the medical school. In 1984, moved to London and studied at Goldsmiths. A dominant figure of the YBAs with more than 80 solo exhibitions, he was awarded the Turner Prize in 1995. Reportedly the richest living artist in the world.

David Hockney
b.1937, Bradford
He studied at Bradford School of Arts and then attended the RCA where he won a gold medal. He moved to California in the 1960s and now lives in France. His 1972 work *Portrait of an Artist (Pool with Two Figures)* is the most expensive artwork by a living artist sold at auction.

Eliot Hodgkin
b.1905, Berkshire
d.1987, London
After establishing himself as a still life painter, he took up the notoriously difficult technique of tempera, at which he excelled. During WWII, he worked for the Ministry of Information and painted bombed ruins and the vegetation growing out of them in his spare time.

William Hogarth
b.1697, London
d.1764, London
He spent part of his childhood in Fleet Prison, where his father was confined for debt. He became an engraver and published his first satirical print in 1721. He began painting around 1726 and achieved rapid success. In 1729, he eloped with the daughter of eminent history painter Sir James Thornhill, which did his career no harm.

Hans Holbein the Younger
b.1497, Augsburg
d.1543, London
Holbein was trained by his father who was also a painter and eventually began working for Sir Thomas More in London, primarily as a portraitist. In 1532 he became court painter to Henry VIII. He died in London, allegedly of the plague.

Wenceslaus Hollar
b.1607, Prague
d.1677, London
In 1636 he moved to London to engrave the Earl of Arundel's art collection. When Charles I fled Whitehall in 1642, Hollar joined the Earl in exile in Antwerp, eventually returning when the country settled under Cromwell. Charles II made him 'Scenographer Royal'.

Chantal Joffe
b.1969, Vermont
Joffe moved to London as a child. After attending the RCA, she began her career painting images from explicit adult publications. In 2006, *Blonde Girl – Black Dress* was awarded the 'most distinguished work in the Summer Exhibition'.

Gwen John
b.1876, Pembrokeshire
d.1939, Dieppe
Sister of artist Augustus John, Gwen studied in Paris, where she settled permanently in 1904. She earned her living modelling for other artists, including Auguste Rodin, who became her lover. There was only one exhibition of her work in her lifetime, but

Augustus prophesied that one day she'd be considered a better artist than him.

Laura Knight
b.1877, Derbyshire
d.1970, London
Attended Nottingham School of Art, where she met and married the painter Harold Knight. In 1903 they moved to Cornwall and became prominent members of the *plein-air* Newlyn School. She was the first woman to be elected as a Royal Academician in 1936. As an Official War Artist, she observed the Nuremberg war crimes trials to create an allegorical painting.

Edwin Landseer
b.1802, London
d.1873, London
He was a child prodigy and favourite painter of Queen Victoria (who considered **him** 'very good looking although rather short') and friends with Charles Dickens. In 1858, he made the four bronze lions for the base of Nelson's Column in Trafalgar Square, despite having no experience as a sculptor. In his final years he suffered from madness, exacerbated by alcohol.

Frederic Leighton
b.1830, Scarborough
d.1896, London
Grandson of the physician to the Russian royal family. His family's wealth furnished him with an allowance for his entire career. Queen Victoria bought his first painting in 1855. He became president of the RA in 1878. He remained a bachelor, though actress and model Dorothy Dene is now

widely believed to have been his mistress, if not secret wife.

Clare Leighton
b.1898, London
d.1989, Connecticut
She studied at Brighton College of Art, then the Slade and Central School of Art and Design. She executed her first wood engraving in 1922 (throughout her life she carved more than 900 woodblocks) and critical attention followed. She also authored several books.

Wyndham Lewis
b.1882, Canada
d.1957, London
He was born on his parents' yacht off Nova Scotia. Expelled from the Slade, he emerged as a leader among the British avant garde artists. He spent a short stint at the Omega Workshops, but quarrelled with its co-founder Roger Fry. In 1914, he formed the Rebel Art Centre, from which grew Vorticism. In later life he concentrated on writing, much of it vitriolic.

L.S. Lowry
b.1887, Lancashire
d.1976, Derbyshire
Lowry studied intermittently at art schools from 1905–25 but only painted in his free time while working as a rent collector and clerk until he retired in 1952. He had his first solo exhibition in 1939. Elected as a Royal Academician in 1962, he famously turned down a CBE, OBE and a knighthood.

Henry Moore
b.1898, Wakefield
d.1986, Hertfordshire
Son of a miner, he studied

at Leeds School of Art. He explored surrealism before settling on organic and human forms, particularly the reclining figure. His drawings of figures sheltering in the London Underground led to popular recognition. He represented Britain at the Venice Biennale in 1948 and turned down a knighthood in 1950.

John Nash
b.1893, London
d.1977, Colchester
He started out a journalist but his brother, the artist Paul Nash, encouraged him to take up painting. They exhibited together in 1913. He was a war artist during WWII, thereafter a devoted painter of the English landscape.

William Nicholson
b.1872, Newark
d.1949, Oxfordshire
Nicholson was initially a printmaker, notably collaborating on poster designs with his artist brother-in-law James Pryde. Afterwards wildly successful as a society portraitist, he is now admired for his still lifes and landscapes. He was Winston Churchill's favourite painting tutor.

Ben Nicholson
b.1894, Denham
d.1982, Hampstead
He trained briefly at Slade, but his head was turned by cubism. Partly influenced by Barbara Hepworth with whom he shared studio space (they later married), he made the first of his landmark 'white reliefs' in 1934. In 1939, he and Hepworth became the nucleus of the St Ives School.

Chris Ofili

b.1968, Manchester

As a young man Ofili rose through Tameside College, Chelsea School of Art and the RCA. At 30, he became the first Black artist to win the Turner Prize. Four years later, he represented Britain at the Venice Biennale. In 2005, he moved to Trinidad.

Samuel Palmer

b.1805, London
d.1881, Surrey

Palmer was 14 when he first exhibited at the RA. Of mystical bent, in 1824 he met William Blake who inspired him to move to Kent and found artists' group The Ancients. After returning to London, his paintings became more conventional. His early work was forgotten until the 1920s, when it influenced Paul Nash.

Cornelia Parker

b.1956, Cheshire

Parker grew up on a farm and studied Gloucestershire College of Art, Wolverhampton Polytechnic and University of Reading. Shortlisted for the Turner Prize in 1997, she was elected as a Royal Academician and awarded an OBE in 2010.

Grayson Perry

b.1960, Essex

Perry studied at Portsmouth College of Art, before exploring ceramics in the 1980s by way of evening classes. His first solo exhibition was in 1984. In 2003, he became the first potter to win the Turner Prize and was awarded a knighthood in 2023.

Thomas J Price

b.1981, London

After attending Chelsea and the RCA, Price has had solo exhibitions at Yorkshire Sculpture Park and National Portrait Gallery. In 2022, *Warm Shores*, his artwork honouring the Windrush Generation, was installed outside Hackney Town Hall.

Eric Ravilious

b.1903, Sussex
d.1942, Iceland

He grew up in Eastbourne and won a scholarship to the RCA under Paul Nash. He was a talented book illustrator and designer of textiles. An official war artist, he died when the air-sea rescue mission in Iceland he was accompanying failed to return.

Paula Rego

b.1935, Lisbon
d.2022, London

Rego's early years were spent under the regime of fascist dictator António Salazar in Portugal. She moved to England 1952 and studied at the Slade, where she met her husband, the painter Victor Willing. She began exhibiting with The London Group in 1962 and was the first living artist to be given an exhibition at the National Gallery in 1992. She was made a Dame in 2010.

Joshua Reynolds

b.1723, Devon
d.1792, London

Apprenticed to Thomas Hudson, he quickly supplanted him as London's leading portraitist. In 1759 he had over 150 sitters. The drawings

he made of classical antiquity and the Old Masters while travelling through Europe were the foundation of his painting. First president of the RA in 1768.

Dante Gabriel Rossetti

b.1828, London
d.1882, Kent

Rossetti's Italian father was a poet and Dante scholar, his sister Christina also a poet. He joined the RA Schools in 1844 and was briefly a pupil of Ford Madox Brown. He founded, with William Holman Hunt and J.E. Millais, the Pre-Raphaelite Brotherhood in 1848.

John Singer Sargent

b.1856, Florence
d.1925, London

Singer Sargent's parents were expat Americans in Italy where he enjoyed early instruction in art. His first appearance at Paris's prestigious Salon in 1877 caused a scandal and he moved to London. By 1900, he was the most acclaimed international society portraitist of the Edwardian era.

David Shrigley

b.1968, Macclesfield

Shrigley studied at the Glasgow School of Art, after which he published his own books of drawings. Notoriety came when one of his works featured on the cover of *Frieze* magazine. Solo exhibitions in Britain and Europe swiftly followed.

Walter Sickert

b.1860, Munich
d.1942, Bath

Born in Germany to a Danish father and Anglo-Irish mother,

he moved to London in 1868, which remained his home for the rest of his life – though he also lived briefly in France and Italy. He acted on stage under the alias 'Mr Nemo', then became Whistler's apprentice. From 1905, he was the main proponent of avant-garde French painting in Britain.

George Stubbs
b.1724, Liverpool
d.1806, London
Mostly self-taught, Stubbs studied anatomy at York Hospital and illustrated medical books for which he learned etching. In 1756, he began the studies that led to his landmark book *The Anatomy of the Horse*. He became President of the Society of Artists in 1772 and was elected as a Royal Academician in 1781.

J.M.W. Turner
b.1775, London
d.1851, London
Turner's mother was committed to an asylum in 1799, dying a couple of years later. His early artistic talent was encouraged by his father who exhibited the drawings in his shop window. He entered the RA and devoted much of his life to raising the status of landscape painting.

Anthony van Dyck
b.1599, Antwerp
d.1641, London
Van Dyck was Rubens' most important assistant and in demand as a portrait painter from a young age. In 1632, he moved to London, where he

was knighted and named court painter to Charles I. He died nine days after the birth of his only daughter.

Rachel Whiteread
b.1963, Ilford
Whiteread studied painting in Brighton and sculpture at the Slade. Awarded the Turner Prize in 1993, she was the first woman to win. A couple of years later she represented Britain at the Venice Biennale.

James McNeill Whistler
b.1834, Massachusetts
d.1903, London
Whistler's family moved to St Petersburg, Russia, where he studied drawing at the Imperial Academy of Science. After a stint in the US Military Academy, he moved to Paris to become an artist. Rejected at the Salon in 1859, he moved to London and began etching. His work eventually achieved international notoriety.

Richard Wilson
b.1714, Penegoes
d.1782, Llanberis
A wealthy relative sponsored his artistic training in London, after which he became a portrait painter. He travelled to Italy in 1750, where he turned to landscape painting. He returned to London 1757 and his classicised versions of the English landscape were immediately fashionable. He was a founding member of the RA in 1768. During the 1770s, his physical and mental health declined and he took to drink, retiring to Wales.

Joseph Wright 'of Derby'
b.1734, Derby
d.1797, Derby
In the mid-1760s, Wright began his 'candlelight' pictures of scientific subjects and industrial scenes, for which he quickly garnered enormous fame. Two years in Italy left him overcome by classical antiquity, and he turned to landscape. He was declined election to the RA.

Lynette Yiadom-Boakye
b.1977, London
Yiadom-Boakye's parents emigrated in the 1960s from Ghana, not long after the country gained independence. She attended Central Saint Martins, Falmouth College of Arts and the RA Schools. The 2018 recipient of the Carnegie Prize, she was short-listed for the Turner Prize in 2013.

Glossary

Avant-garde
A French term that translates as 'advance guard' in English, it stems from the belief that art could help bring about a new society. Nowadays it's used to describe any radical artwork that explores new forms or ideas.

Caricature
An often satirical portrait of a person that ludicrously exaggerates their most characteristic features, usually in order to poke fun at them.

Cast
An artist will often make a sculpture by modelling a form in clay, wax or plaster, which is then used to create a mould. The mould is then filled with a molten metal to create a cast.

Composition
The arrangement of figures or other elements, such as trees or hills, in a painting to create a sense of harmony or balance. Artists have historically used geometry and the golden ratio to create ideal compositions.

Conversation piece
A painting of a group of people, usually family members or close friends, arranged as if in conversation in an everyday surrounding. This genre was popularised by William Hogarth (p.36) in the 18th century.

Dada
An artistic and cultural movement formed during the First World War that rejected social and aesthetic convention in favour of satirical and absurd artworks. Revolted by the horrors of conflict, they believed traditional values had led to war and had to be destroyed.

Edition
A work of art produced as part of a series or set of multiple copies. Prints are one of the most common kinds of editions.

Engraving
A method of printmaking originating in the 15th century. A burin (fine chisel) is used to score a design onto a metal plate, which is then coated in ink and pressed onto paper. In the 20th century, artists like Clare Leighton (p.80) experimented with wood engravings inspired by folk art.

Enlightenment
A scientific and philosophical revolution in the 18th century that aimed to free human understanding from superstition and traditional beliefs in favour of a rational inquiry into all aspects of life.

Etching
A method of printmaking originating in the 16th century and used by artists such as James Gillray (p.48) that involves making marks on a wax-coated metal plate, which is then dipped in acid and coated with ink before being pressed onto paper.

Figurative
A term used to describe the work of artists such as Francis Bacon (p.100) and Lucian Freud (p.98) whose work, although not realist, draws on figures and objects from the real world – unlike abstract art.

Fresco
A painting executed in watercolour on a wall or ceiling while the plaster is not quite dry so that the colours sink into the wall and become part of it.

Gothic
A style of medieval art that developed in 12th-century northern France but soon spread across Europe, including Britain. *The Wilton Diptych* (p.20) is an exemplary example. It was called 'Gothic' because later art critics thought it was barbaric, compared to the classical art of the Renaissance. However, it was celebrated by John Ruskin and inspired a great deal of Victorian architecture and art.

Grand manner
A style of art developed in the 18th century by artists such as Joshua Reynolds (p.46) which they thought appropriate for the expression of lofty ideals and great themes. It encouraged artists to draw on classical art and the Renaissance masters rather than painting from nature.

Installation
A popular form of contemporary art, an installation is usually a large work (that can in itself contain multiple artworks) designed for a specific place, like Chris Ofili's *The Upper Room* (p.130).

Old Master
A pre-eminent painter of great skill working in Europe

between the 13th and 18th centuries, such as Hans Holbein (p.22) and Anthony van Dyck (p.32).

Op Art

A style of abstract art developed in the 1960s in which geometrical patterns and colour contrast to create optical illusions that often result in canvases that look, to the human eye, as if they're flickering.

Painterly

A style of painting characterised by loose, visible brushstrokes and an emphasis on texture. See Walter Sickert (p.68).

Performance art

Emerging in the 1960s, performance art describes a live presentation by an artist that could include choreography, music or speech. It is often recorded through video, photography (as with Helen Chadwick, p.116) or written documentation.

Perspective

In terms of art, this means the representation of three-dimensional objects within two-dimensional artworks. It requires the artist to use various techniques to create an illusion of space and depth on the canvas. Sometimes, as with *The Ambassadors* (p.22), these tricks can result in surprising effects.

En plein air

The act of painting outside, in the open air, away from the studio or classroom so as to better capture shifting patterns of light and weather.

Pioneered by John Constable (p.52) in Britain, but largely popularised by later French Impressionists.

Renaissance

A great cultural revival that began in 15th-century Florence inspired by the art and literature of ancient Greece and Rome. Renaissance art reached Britain in the middle of the 16th century partly via the influence of Hans Holbein (p.22).

Repoussoir

A technique used to create a sense of depth and space in a painting by positioning a figure or object in the foreground, so that the main action seems to occur in the distance. See Samuel Palmer (p.54).

Salon

Originally, the official art exhibitions sponsored by the French government the word came to be used for any large exhibition put on by the Parisian art academies, who typically refused to exhibit avant-garde work. This forced artists to set up alternative, anti-academic salons where they could exhibit modern and radical art.

Satire

Art that uses derisive humour to expose the faults or absurdities of a situation or person, usually someone in power. The 18th century was a heyday for satire with William Hogarth (p.36) at the helm, but contemporary satirists like Banksy (p.144) and David Shrigley (p.146) are leading a new wave.

Street art

Urban artworks created in a public space, usually illegally or at least without permission. The art is free to view and tends to involve graffiti or murals. Street artists like Banksy (p.144) have gained international recognition in recent decades.

Sublime

An artistic ideal developed in the 18th century that aimed to inspire awe in the viewer, or even overwhelm them completely. Artists such as J.M.W. Turner (p.58) created powerful works that use storms and wild landscapes to explore the sublime.

Tempera

A fast-drying paint made by mixing coloured pigments with egg yolk. It was the primary medium in the medieval and early Renaissance. However, it was still preferred by some later artists such as William Blake (p.50) and Eliot Hodgkin (p.104).

Vorticists

An avant-garde group formed in London in 1914 by Wyndham Lewis in the hopes of creating a new kind of art that could express the whirl and rush of the modern present. It drew on the sharp, jagged imagery of machines.

Working model

Also known as a maquette, a working model is a smaller, draft version of a sculpture that helps the artist to try out different approaches.

Picture credits

Lindisfarne Gospels © British Library Board. All Rights Reserved / Bridgeman Images; The Wilton Diptych © Bridgeman Images; The Ambassadors © Bridgeman Images; The Field of the Cloth of Gold, courtesy of Royal Collection Trust / © His Majesty King Charles III, 2023 / Bridgeman Images; Portrait of a Young Man, courtesy of Fletcher Fund; The Cholmondeley Ladies, courtesy of Tate / Tate Images; Lord John Stuart and his brother Lord Bernard Stuart © Bridgeman Images; 'Long View' of London, courtesy of Royal Collection Trust / © His Majesty King Charles III 2023; Marriage A-la-Mode II – The Tête à Tête © Bridgeman Images; Mr and Mrs Andrews © Bridgeman Images; Whistlejacket © Bridgeman Images; Experiment on a Bird in the Air Pump © Bridgeman Images; Llyn-y-Cau, Cader Idris © Tate / Tate Images; The Ladies Waldegrave © National Galleries of Scotland / Bridgeman Images; Fashionable Contrasts, Or the Duchess's little Shoe yielding to the Magnitude of the Duke's Foot © Bridgeman Images; Newton © Tate / Tate Images; Hay Wain © Bridgeman Images; The Weald of Kent © Bridgeman Images; Eos, courtesy of Royal Collection Trust / © His Majesty King Charles III, 2023 / Bridgeman Images; Rain, Steam, and Speed – The Great Western Railway © Bridgeman Images; Nocturne in Black and Gold, The Falling Rocket, 1875 © Detroit Institute of Arts / Bridgeman Images; Proserpine, photo © Christie's Images / Bridgeman Images; Carnation, Lily, Lily, Rose © Tate / Tate Images; Flaming June, photo© The Maas Gallery, London / Bridgeman Images; Gallery of the Old Bedford © National Museums Liverpool / Bridgeman Images; Self-Portrait © Tate / Tate Images; The Lustre Bowl with Green Peas © National Galleries of Scotland; Over the Top © IWM Art. 1656; The Cornish Coast, courtesy of National Museums & Galleries of Wales / © Estate of Dame Laura Knight. All rights reserved 2023 / Bridgeman Images; Interior with Duncan Grant © estate of Vanessa Bell. All rights reserved, DACS 2023. Photo credit: Williamson Art Gallery & Museum; Clare V. Leighton, Lap Full of Windfalls 1935, wood engraving, Gift of Gabby Pratt, image courtesy of The Mint Museum, Charlotte, NC. By permission of the Estate of Clare Leighton; Cuckmere Haven © Towner Collection. Towner Eastbourne / Bridgeman Images; Stephen Spender © Potteries Museum and Art Gallery, Stoke-On-Trent / © Wyndham Lewis Memorial Trust. All rights reserved 2023 / Bridgeman Images; Summer © Harry Epworth Allen, Glynn Vivian Art Gallery / Bridgeman Images by permission of Harry Epworth Allen Estate, Derwent Wye Fine Art. Derbyshire;

An Opinionated Guide to British Art
First edition

Published in 2023 by Hoxton Mini Press, London
Copyright © Hoxton Mini Press 2023. All rights reserved.

Text by Lucy Davies
Editing by Octavia Stocker
Design by Tom Etherington
Additional design by Richard Mason
Production by Sarah-Louise Deazley
Proofreading by Lizzy Silverton at First Pages

Thank you to the following: Rosa Bacile, Alejandro Basterrechea,
Sophie Bowness, Bea Bradley, Jennifer Carding, John Cornish, Mark
Hodgkin, Niall Hodson, Karen Lawson, Amberley Jamieson, Sophie
Leighton, George Lionel Barker, Rob Lloyd, Dave McCall, Jarek
Miller, Katrina Millar, David Naylor, Harriet Olsen, Adam Petitt, Sara
Renaud, Frankie Rossie, Fintan Ryan, Leah Saltoun, Iain Smedley and
Moet Wyborn.

A CIP catalogue record for this book is available from the British
Library.

ISBN: 978-1-914314-45-2

Printed and bound by C&C, China

Hoxton Mini Press is an environmentally conscious publisher, commit-
ted to offsetting our carbon footprint. This book is 100 percent carbon
compensated, with offset purchased from Stand For Trees.

For every book you buy from our website, we plant a tree:
www.hoxtonminipress.com